# TURNER'S OXFORD

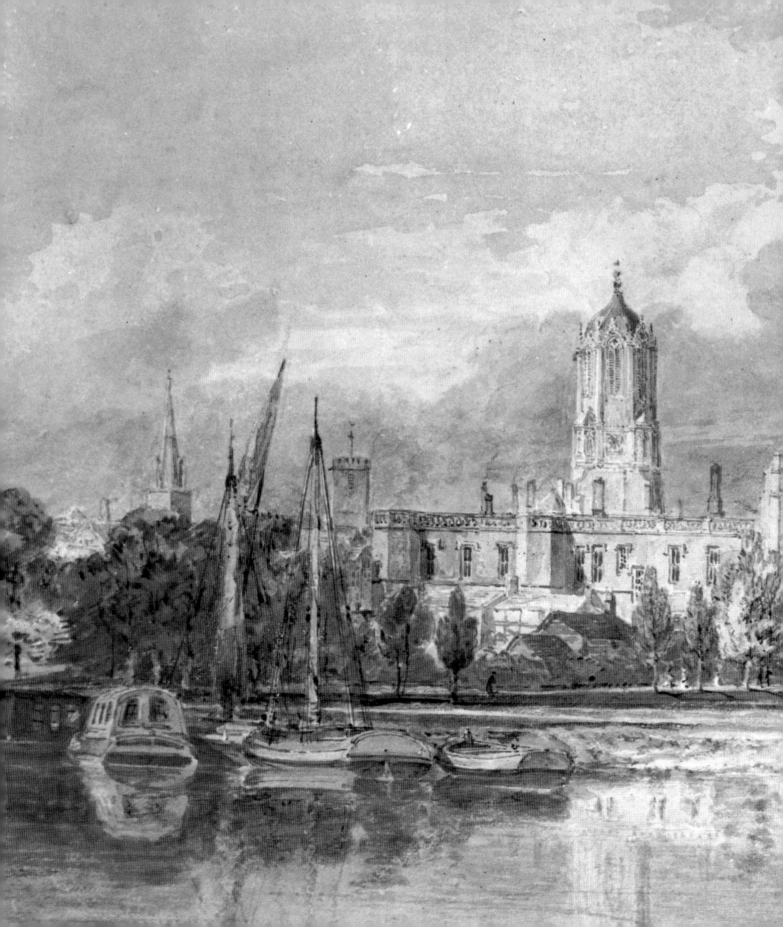

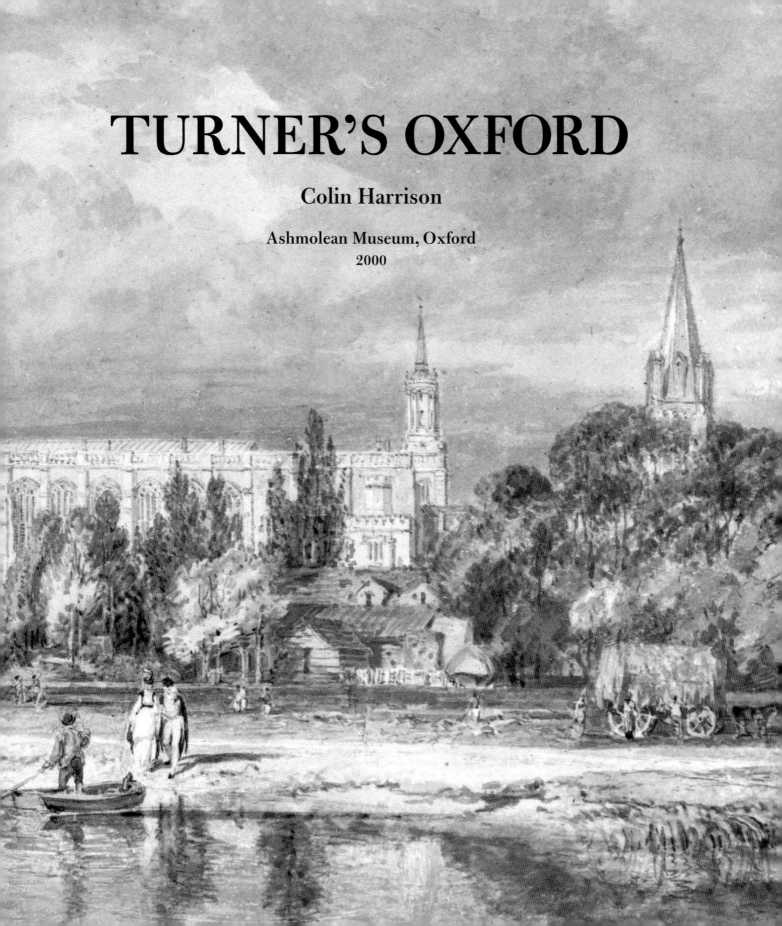

# TURNER'S OXFORD

## Colin Harrison

Ashmolean Museum, Oxford
2000

*For* A. & A., C. & H. (& C.)

Published to coincide with an exhibition in the Ashmolean Museum,
20 June to 2 September 2000. Exhibition sponsored by Coutts and Co., and
Darbys Mallam Lewis, Solicitors.

Catalogue published with the aid of generous subventions from
the Paul Mellon Centre for Studies in British Art and from the
Elias Ashmole Group.

ISBN  1 85444 137 X paperback
        1 85444 138 8 hardback

BRITISH LIBRARY CATALOGUING IN PUBLICATION DATA
A catalogue record of this book is available from the British Library

Designed and set in Monotype Fournier by Tim Higgins
Printed and bound in Great Britain by BAS Printers Limited,
Over Wallop, Hampshire

COVER ILLUSTRATION: Detail of *Christ Church College, Oxford*
(cat. no. 54)
FRONTISPIECE: Detail of *South View of Christ Church, &c from
the Meadows* (cat. no. 40)

# Contents

## Lenders

Aberystwyth, University College, Wales: 30
Cambridge, The Syndics of the Fitzwilliam Museum: 17
Leeds City Art Galleries: 26
London, The Trustees of the British Museum: 15, 16, 18, 40b, 42b, 43b, 48b, 48c, 50c, 51b, 53b
London, The Trustees of the Tate Gallery: 1–3, 6–8, 9, 13, 22, 27–9, 31, 34, 36, 39, 46, 52, 55–65
London, Messrs Thomas Agnew & Son: 54
Loyd Collection, on extended loan to the Ashmolean Museum: 51

Manchester, Whitworth Art Gallery, University of Manchester: 14
Manchester, City Art Gallery: 66
Oxford, The Delegates of the University Press: 40c, 50b, 50d
Mr and Mrs P. A. J. Abbott: 4
Private Collections: 5, 19a, 24, 53a

## Acknowledgements

Anyone embarking on work on Turner is indebted to the cohorts of scholars and amateurs who have grappled with the artist's reticence and his associates' careful destruction of so many invaluable documents. While preparing even a relatively modest exhibition, I have incurred great debts to many scholars and museum curators. Among Turner specialists, I am particularly grateful to Dr James Hamilton, Ian Warrell, and Andrew Wilton. Dr Selby Whittingham has also offered good advice.

The staff in the lending institutions have been unfailingly helpful. At the Tate, Miss Sarah Taft has enabled me to make the most of the limited opening hours of the Study Room in the Clore Gallery. Elsewhere, I am indebted to Antony Griffiths, Dr Kim Sloan, and Miss Sheila O'Connell at the British Museum; Charles Nugent at the Whitworth Art Gallery; Mrs Melva Croal and Andrew Loukes at the Manchester City Art Gallery; Robert Meyrick and Neil Holland at Aberystwyth; Mrs Corinne Miller at Leeds; Miss Jane Munro at the Fitzwilliam; Dr Martin Maw at O.U.P; Andrew Wyld and Mrs Susan Sloman, Agnew's; and several private lenders. Among other friends and colleagues who have helped me in various ways are Mr and Mrs R. E. Alton; Sir Howard Colvin; Mrs Judith Curthoys, Christ Church; Mrs Elizabeth Boardman, Oriel; Dr Jerrold Northrop Moore; Tim Marshall; Sir Stephen and Lady Tumim; Dr and Mrs J. J. L. Whiteley; Miss Anne Steinberg, Victoria and Albert Museum; the staff of the Centre for Oxfordshire Studies; Miss Amina Wright at Kenwood; Jeremy Rex-Parkes and Lynda McLeod, Christie's; Henry Wemyss and Miss Loveday Manners-Price, Sotheby's; and Charles Leggatt at Dulwich, who led me to the owner of Wyatt's second oil painting. I owe a particular debt to Julian Munby, who has patiently identified the street scenes and, with Michael Coker, the distant views too. With Miss Kate Heard, he has also shared with me the exhausting and largely thankless task of reading newspapers on microfilm.

Finally, Martin Wyld kindly arranged for the *High Street, Oxford* to be examined at the National Gallery, with the willing consent of the owner, Christopher Loyd. This painting usually hangs on long-term loan in our permanent galleries, near two others by Turner from the same collection. It is a great privilege to have them here.

COLIN HARRISON

# Foreword

The greatest English artist, J. M. W. Turner, had a profound and long-lasting love of Oxford. The city and its architecture provided subjects to which he returned again and again throughout his career. Turner travelled extensively in Britain and Europe, sketchbook in hand, and yet he made more finished watercolours of Oxford than of any other place, even Venice. Turner's relationship was with both town and gown. Between 1799 and 1811, he provided no fewer than ten watercolours for the Clarendon Press, to be engraved as headpieces for the *Oxford Almanack*, the University's broadsheet calendar. He also received important patronage from the print-seller, James Wyatt, who served as Lord Mayor of the city, a relationship which is recorded in a fascinating series of letters between the two men. It is therefore entirely appropriate that the Ashmolean, the museum of the University which also serves the city, should celebrate his achievement with an exhibition which brings together a large group of his watercolours and paintings of Oxford. The exhibition has been organised and the catalogue written by my colleague, Colin Harrison, who has made a significant contribution to our knowledge of Turner's career and in particular has shed important light on his earliest years and his friendship with Wyatt. However, all exhibitions require a large team within the museum and I would also like to extend my thanks to all those who have collaborated on this project, in particular,

the Registrar, Geraldine Glynn; David Gowers and the Photography Studio and Robert Johnston of the Workshop team.

Lenders have been extremely generous, and we are particularly grateful to the Trustees of the Tate Gallery and the British Museum, who have lent major groups of works. I would also like to thank our colleagues at the Whitworth Art Gallery in the University of Manchester, the Manchester City Art Gallery, Leeds City Art Gallery, The University of Wales at Aberystwyth, and the Fitzwilliam Museum in Cambridge. Agnew's have lent a major watercolour as have a number of private lenders, to all of whom we are profoundly indebted. We have a very special debt of gratitude to Christopher Loyd, a long-term friend and supporter of the Ashmolean, whose glorious painting of the High Street is on permanent loan to the Museum and plays a key role in this exhibition.

It would have been impossible for the Ashmolean to mount this ambitious exhibition without sponsorship and we are very pleased to be co-operating with Darbys Mallam Lewis, one of Oxford's leading firms of solicitors, and Coutts and Co., which has recently established a branch in the city. The collaboration has been a great pleasure for us and, I hope, for them.

DR CHRISTOPHER BROWN
*Director*

# Preface

Andrew Wilton has written of Turner the indefatigable traveller and filler of innumerable sketchbooks that 'geographical orientation could be said to have been his natural mode of organisation'.[1] This has been the defining motivation for a series of exhibitions, at the Tate Gallery and elsewhere, examining Turner's extensive tours, the sketchbooks recording them, and the finished works in oil or watercolour completed after the artist's return to his studio, generally during the winter months preceding the opening of the exhibitions at the Royal Academy and other venues in the spring. Oxford was never the subject of a specific tour, nor of a single publication. Yet Turner returned repeatedly, and his work made a very distinctive contribution to the iconography of the city.

*Turner's Oxford* is the second in an occasional series of exhibitions exploring art in Oxford, and offers an instructive contrast with the first, *John Malchair of Oxford, Artist and Musician* (1998). For, whereas Malchair lived in Oxford for nearly forty years, and recorded the demise of the mediæval city in a long series of deeply personal drawings, Turner's watercolours are essentially public performances, popularised in engravings or drawn for the tourist. It is commonplace to assert that, as such, they are no different from any other topographical artist's. Yet, each work of art is the product of a conscious choice, and the artist's reasons for choosing a particular subject, a particular point of view, or indeed of not drawing a subject which might be 'obvious' to others, are deliberate and must be respected and, if possible, explained. Turner's views of Oxford demonstrate many of the main technical and aesthetic preoccupations of his early years, the continuity of development from the antiquarian young man to the wholly personal preoccupations of his middle years, and a resounding rebuttal of Ruskin and his followers who have deliberately maintained, against all the evidence, that Turner was somehow not being true to himself, or producing an authentic voice, in the 1790s. Finally, the exhibits, despite depicting only one city, are as varied as those of even the most idealistic and hypothetical Turner exhibition, from juvenile drawings and watercolours to commissioned works and preparatory sketches, copper plates, oil paintings, and the technical innovation of the 'colour beginning' of the 1820s and 1830s. The result is not intended simply as another anthology of views, but a demonstration of Turner's development and his contribution to the iconography of the most beautiful city in early nineteenth century England.

# Introduction: Oxford in Turner's Lifetime

Before the industrial revolution, Oxford was one of the largest cities in England outside London: The survey of 1781 lists it fourth after Manchester, Liverpool, and Bristol.[1] Its prosperity was derived from two sources: the University, and the fertile agricultural land of the Thames Valley surrounding it. It was described as follows in one of the principal publications of Turner's youth, William Combe's *An History of the River Thames*, published in 1794:

*Oxford, the capital of the county which bears its name, is a city, an episcopal see, and, according to the most comprehensive sense of the expression, the first university in the world. Including the suburbs, it is upwards of two miles from east to west, and about a mile from north to south. The city, properly so called, comprehending the part which was anciently encompassed with a wall, is of an oblong form, and with more than two miles in circumference. It is seated on an almost imperceptible eminence, at the conflux of the Thames and the Cherwell, and surrounded with hills, meadows, and fields in arable cultivation. The meadows, which lie chiefly to the south and west, are about a mile in extent, from whence the hills rise gradually to a pleasing elevation, and bound the prospect. Towards the east is a continual rise of near two miles to the top of Shotover-hill, a very commanding summit; and to the north, there is a considerable range of level country.*[2]

Oxford was best known as the seat of the senior of the two universities in England, established, according to legend, by King Alfred the Great. This consisted of twenty colleges, founded between 1249 (University College) and 1714 (Worcester), each independent, self-governing, and only loosely connected with each other. During Turner's lifetime, the university admitted some 250 undergraduates a year, an increasing number of whom took degrees, which were gradually being formalised by written examination and awarded as an honours degree in different classes. Nevertheless, there was a great deal of time for the nobleman and gentleman commoner to indulge in sports and hobbies, to hunt or walk, go to a theatre (outside the city) or drink. Undergraduate commoners were obliged to keep four terms a year, attend lectures and classes, and participate in various scholarly 'exercises'.[3]

The city they lived in for much of the year (fig. 1) had only recently lost some of its mediæval character, and was still essentially unplanned. It had grown up around two main thoroughfares, Cornmarket and St Aldate's running from north to south, and the High Street from east to west. Various attempts had been made during the eighteenth century to rationalise the planning, most notoriously Nicholas Hawksmoor's plan to divide Oxford into a *forum civitatis* and a *forum universitatis*, which would have literally cast in stone the division between town and gown; these had thankfully come to nothing.[4] The Mileways Act of 1771

had brought about numerous changes, such as the widening of many streets, especially Broad Street, the removal of Carfax Conduit and the construction of a new market on the High Street. In spite of these improvements, mediæval Oxford could still be easily found, especially in the smaller streets and the numerous alleys off the High Street. The college authorities had meanwhile been inserting into their largely Gothic domains classical buildings which did not jar with their surroundings. The erudite amateur architects, Dean Aldrich of Christ Church, and George Clarke of All Souls, began the process at the beginning of the eighteenth century, and James Wyatt continued with renewed energy in the last quarter. Between, Hawksmoor, Gibbs, and Henry Keene produced some of their most imaginative designs. So, by the 1790s, when Turner first drew the buildings of Oxford, the city could boast outstanding examples of most periods, from the Saxon tower of St Michael at the Northgate and the church of St Peter in the East, to the High Gothic of Christ Church Cathedral and the Divinity School, the eccentric pseudo-Gothic of Hawksmoor's All Souls, the majestic Baroque of the Radcliffe Camera, and grandiose neo-classical schemes at Queen's College and Christ Church. For the antiquary, there were the remains of the royal palace of Beaumont, the romantic associations of Godstow Nunnery and Rewley Abbey, but otherwise few picturesque ruins.

Many travellers came to Oxford, as the almost innumerable editions of the *Pocket Companion for Oxford* and the *New Oxford Guide* testify. They combined a tour of the city with a visit to one of the spectacular country houses in the vicinity, the splendour of Blenheim and its Claudean landscape by Capability Brown, or the ideal and more recent estate created by Lord Harcourt at Nuneham,

celebrated in Mason's poetry. Some visitors revelled in the historic links with Jacobitism: when Mary Shelley's hero, Frankenstein, visited Oxford, for example, he found that,

*The memory of that unfortunate king [Charles I], and his companions, the amiable Falkland, the insolent Goring, his queen, and son, gave a peculiar interest to every part of the city, which they might be supposed to have inhabited. The spirit of elder days found a dwelling here, and we delighted to trace its footsteps. If these feelings had not found an imaginary gratification, the appearance of the city had yet in itself sufficient beauty to obtain our admiration.[5]*

As an important university and tourist attraction, Oxford inspired a large body of literature, much of it ephemeral, but including some extended pieces of lasting value. This has been surveyed recently,[6] but the art of the period is much less studied. When the German violinist and drawing master, John 'Baptist' Malchair, came to Oxford in 1759, he believed that 'Oxford being a national seminary was a desirable place for an Artist to settle in as He might become known ... to persons coming from every district in the Kingdom'.[7] Oxford did indeed offer plentiful material for topographical artists, but for those with higher claims, it did not provide the necessarily varied viewpoints, nor, owing to the great wealth of some of the colleges and the building boom of the seventeenth century, enough picturesque ruins. Among native artists, Malchair held sway, teaching his amateur pupils the delights of sketching from nature and observing closely the humble and everyday as well as the grand. His many drawings

1 (RIGHT) Joseph Fisher after William Delamotte, *A Pictorial Plan of the University and City of Oxford*, 1840. Ashmolean Museum (Hope Collection)

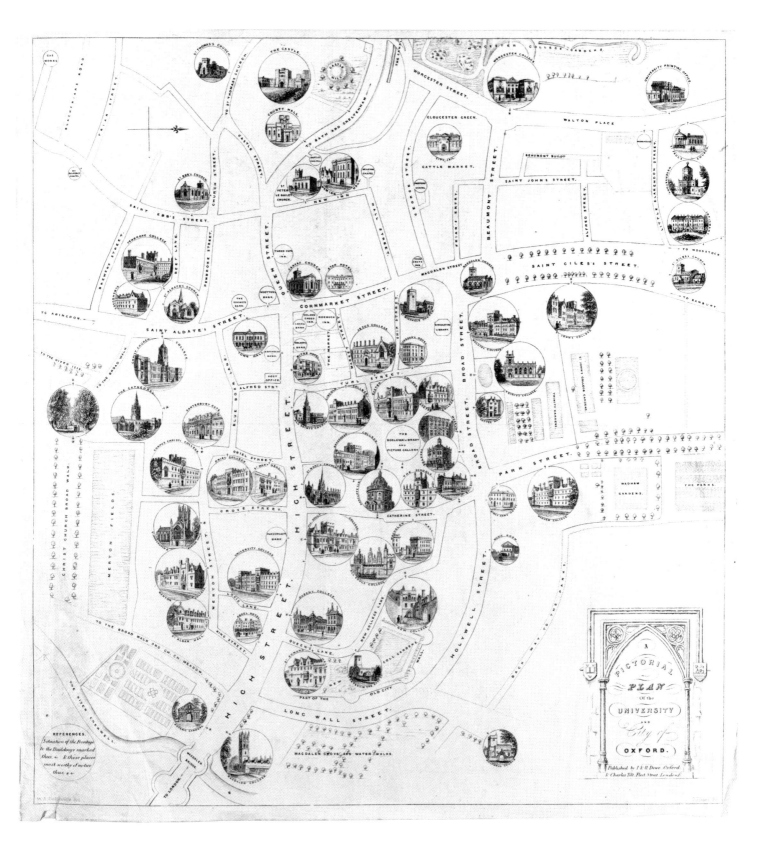

of Oxford record the mediæval city as it was being pulled down in the 1770s, not merely the grand public buildings, but also the picturesque corners, often unprepossessing in themselves, which he imbued with magical effects of light and atmosphere. In sharp contrast were the tourists; indeed, in later life, Malchair strongly criticised 'persons who draw passing hastily through picturesque Countrys, making a number of black lead pencil outlines & leaving them to be finished & effects given at home,'[8] so numerous had the tourists become. Malchair remained active until *c.* 1795, when his place as drawing master was taken by Dr William Crotch, William Delamotte, and a succession of local artists, of whom the most distinguished was William Turner, known as Turner of Oxford, the greatest exponent of the 'exhibition watercolour' in the first half of the nineteenth century.

Despite the strictures of the high priest of the cult of the Picturesque, William Gilpin, who specifically omitted Oxford from his tours, later artists established the journey up the Thames to Oxford as one of the most popular of picturesque tours, from Samuel Ireland's *Picturesque Views* *on the River Thames* of 1792, to John Hassell's *Excursions of Pleasure and Sports on the Thames* of 1823 and beyond. For the city itself, artists and scholars had ensured that the image of Oxford from David Loggan in the seventeenth century to Joseph Skelton in the nineteenth was essentially antiquarian, though a correspondent in the *Gentleman's Magazine* could complain that the university's calendar, the *Oxford Almanack*, was not sufficiently so.[9] It was only in Turner's lifetime that less literal and more pictorial views were made and published, notably by the Rookers in the 1770s and 1780s. The aquatints of Thomas Malton the Younger, first published in 1802 and completed and reissued by his son in 1810, give, with Ackermann's illustrations to William Combe's *A History of the University of Oxford* (1814), the most authoritative and comprehensive visual account of Oxford in Turner's lifetime. If Turner himself became the most distinguished artist to study Oxford, he remained essentially a tourist in the lineage of Rooker and Malton, but private study and a series of commissions over nearly forty years made him as familiar with many of the buildings of Oxford as any resident.

1 (LEFT) *Distant View of Oxford from the South*, 1789. Mr and Mrs P. A. J. Abbott (Photo: Phillips) (cat. no. 4)

2 (BELOW) *A View of the City of Oxford*, c. 1787–8. Tate Gallery (cat. no. 2)

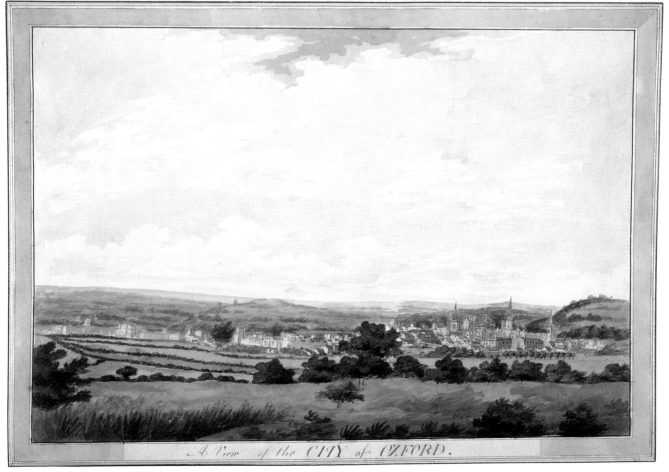

A View of the CITY of OXFORD.

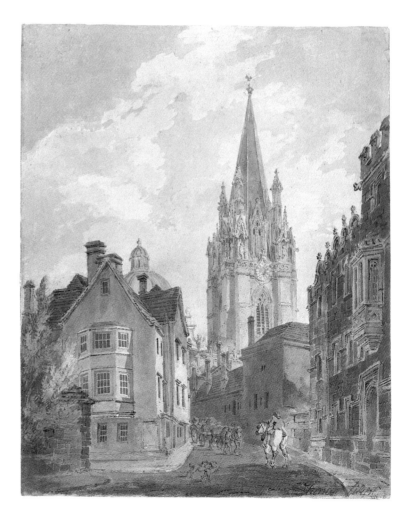

3 (RIGHT) *St Mary's Church and the Radcliffe Camera from Oriel Lane*, c. 1793. Tate Gallery (cat. no. 8)

4 (BELOW) *Folly Bridge*, c. 1794. University of Wales, Aberystwyth (cat. no. 30)

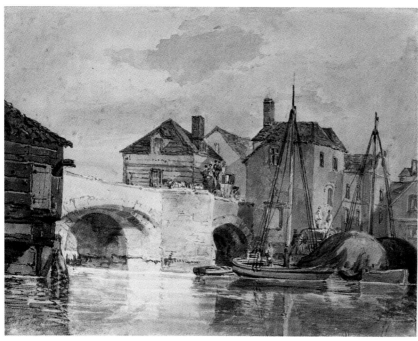

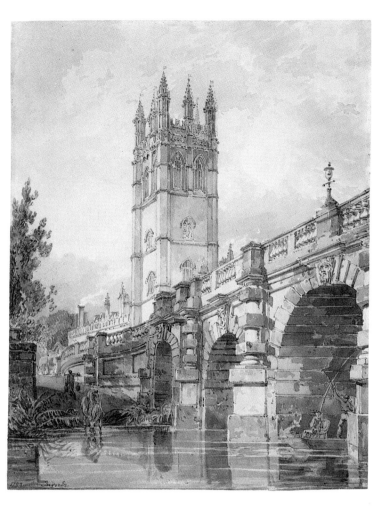

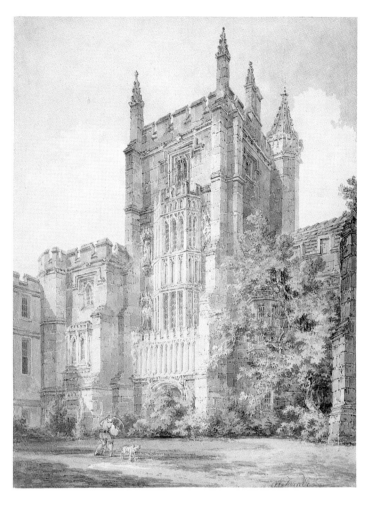

5 *Magdalen Tower and Bridge*, 1794. Whitworth Art Gallery, University of Manchester (cat. no. 14)

6 *Founder's Tower, Magdalen College*, c. 1794. British Museum (cat. no. 18)

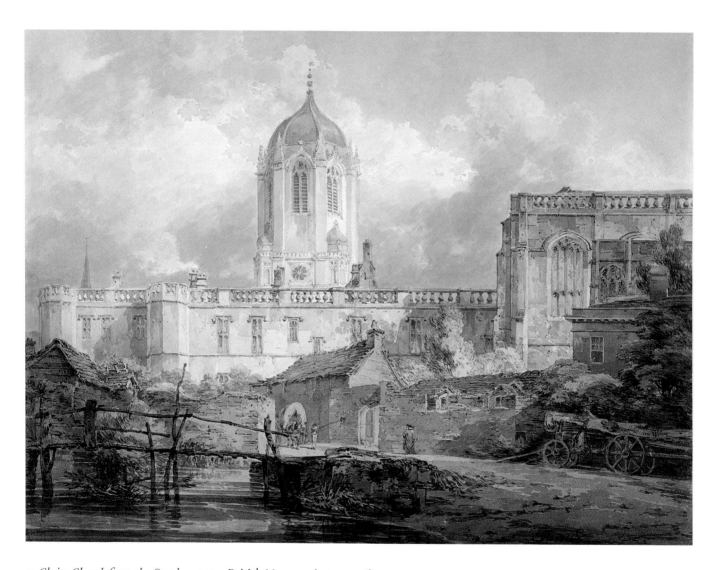

7 *Christ Church from the South*, c. 1794. British Museum (cat. no. 16)

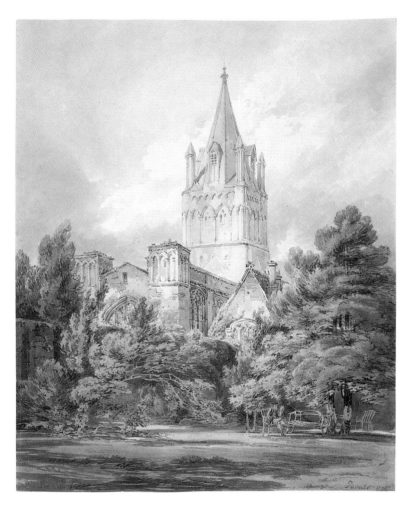

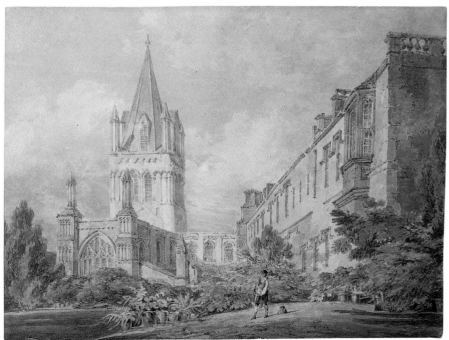

8 *Christ Church Cathedral from the Canons' Garden*, 1794. Fitzwilliam Museum, Cambridge (cat. no. 17)

9 *Christ Church Cathedral from the Dean's Garden*, *c.* 1795. Private Collection (cat. no. 19a)

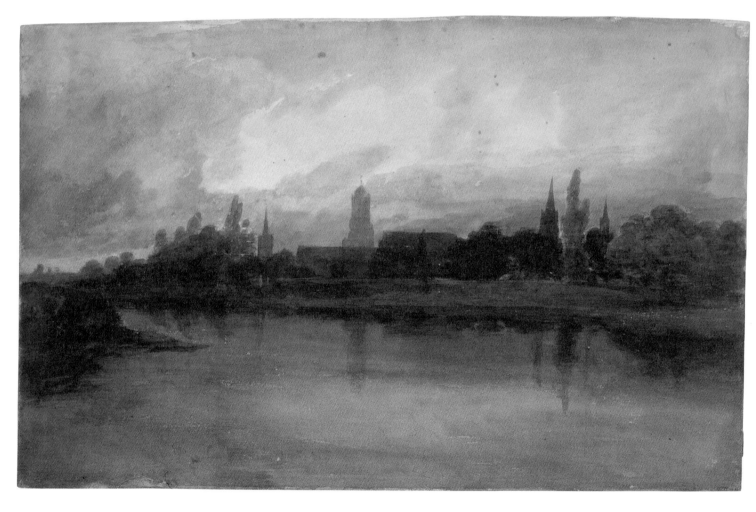

10 *Christ Church from the Isis*, c. 1799. Tate Gallery (cat. no. 34)

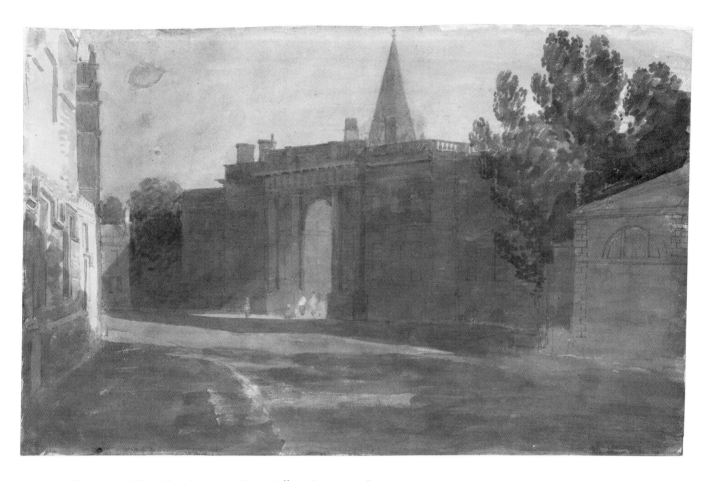

11 *Canterbury Gate, Christ Church, c.* 1799. Tate Gallery (cat. no. 22)

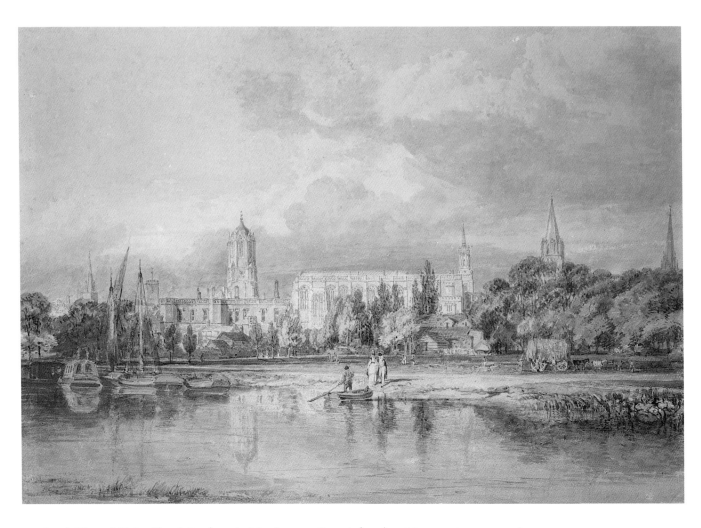

12  *South View of Christ Church &c. from the Meadows*, 1798–9. Ashmolean Museum (cat. no. 40a)

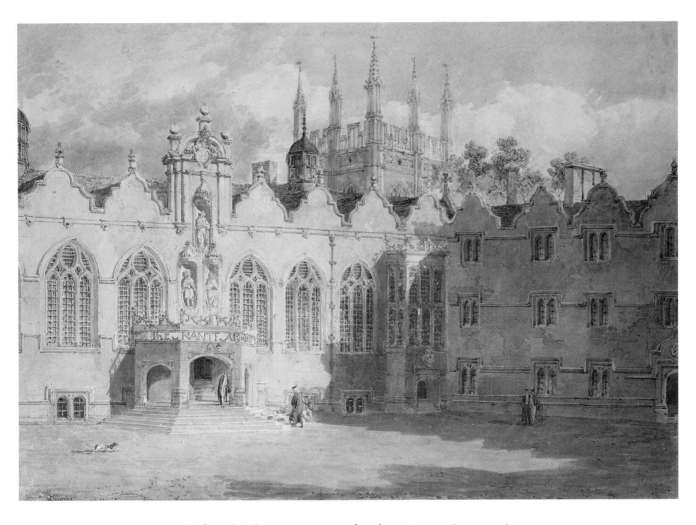

13 *A View of the Chapel and Hall of Oriel College &c*, 1798–9. Ashmolean Museum (cat. no. 41)

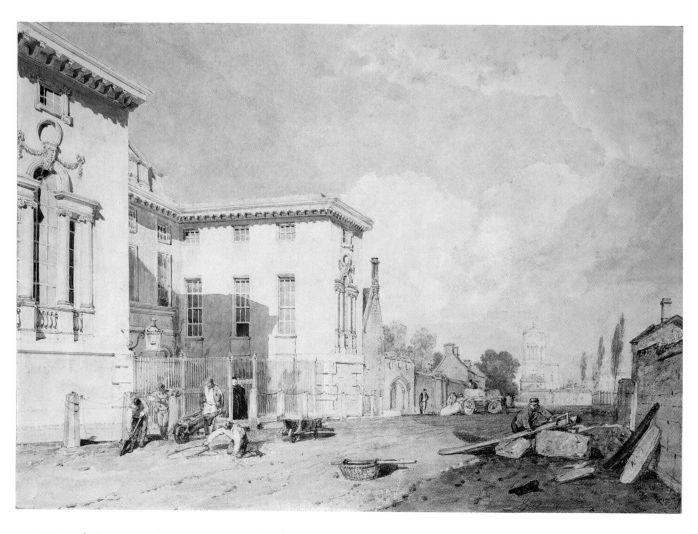

14 *A View of Worcester College, &c*, 1803–4. Ashmolean Museum (cat. no. 43a)

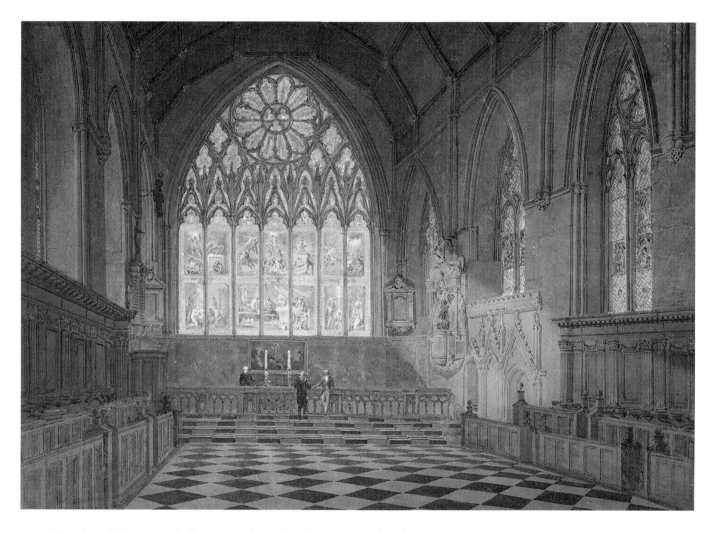

15  *Inside View of the East End of Merton College Chapel*, 1800–01. Ashmolean Museum (cat. no. 42a)

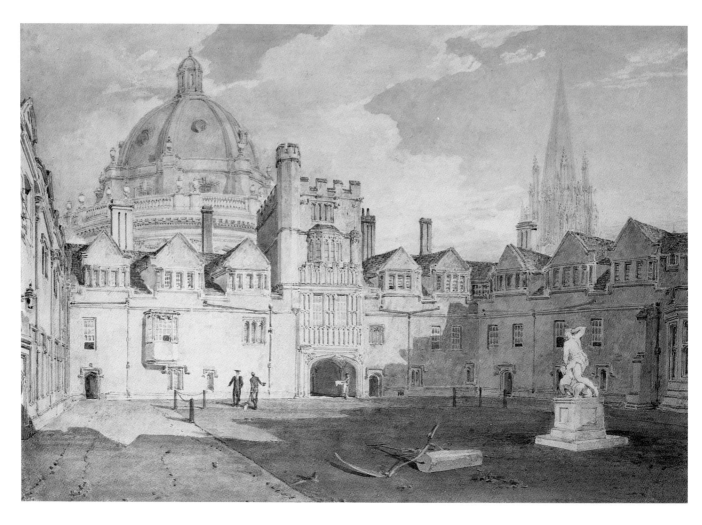

16 *A View of the Inside of Brazen Nose College Quadrangle*, 1803–4. Ashmolean Museum (cat. no. 44)

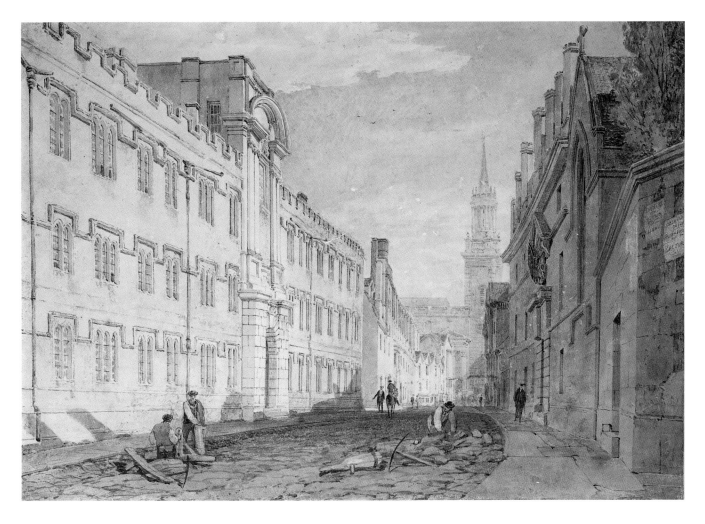

17 *View of Exeter College,* All Saints Church &c. from the Turl, 1803–4. Ashmolean Museum (cat. no. 45)

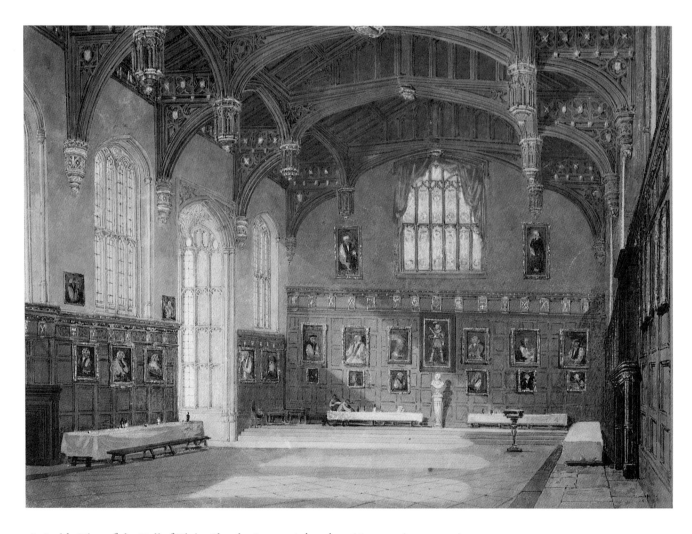

18 *Inside View of the Hall of Christ Church*, 1803–4. Ashmolean Museum (cat. no. 47)

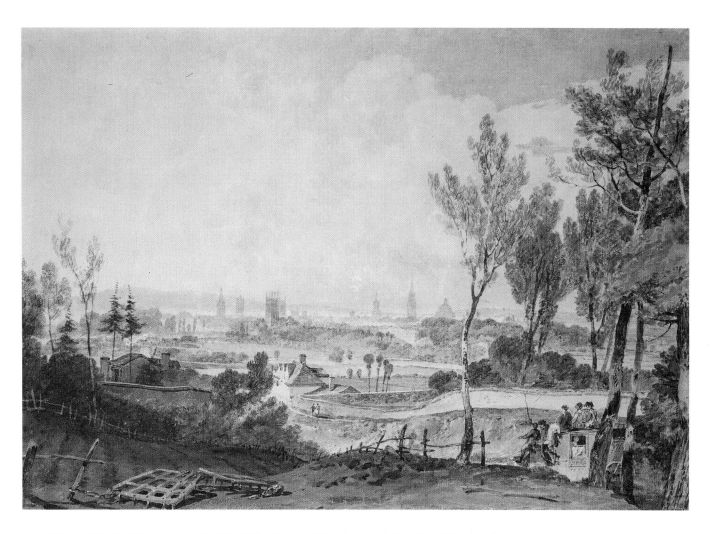

19 *A View of Oxford from the South Side of Heddington Hill*, 1803–4. Ashmolean Museum (cat. no. 48a)

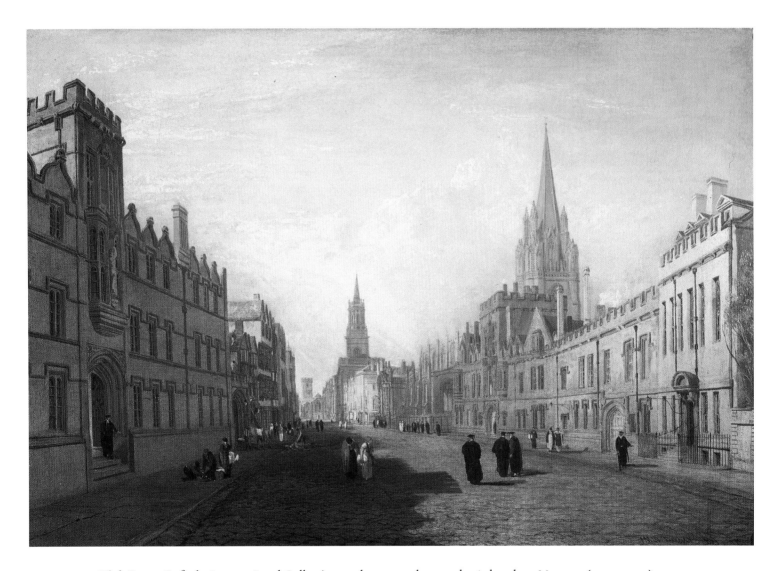

20 *High Street, Oxford*, 1809–10. Loyd Collection, on long-term loan to the Ashmolean Museum (cat. no. 51a)

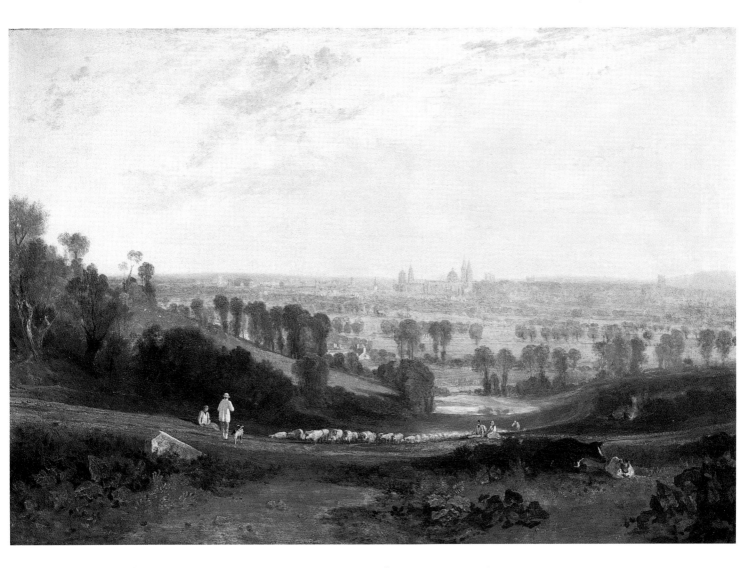

21 *A View of Oxford from the Abingdon Road*, 1811–12. Private Collection (cat. no. 53a)

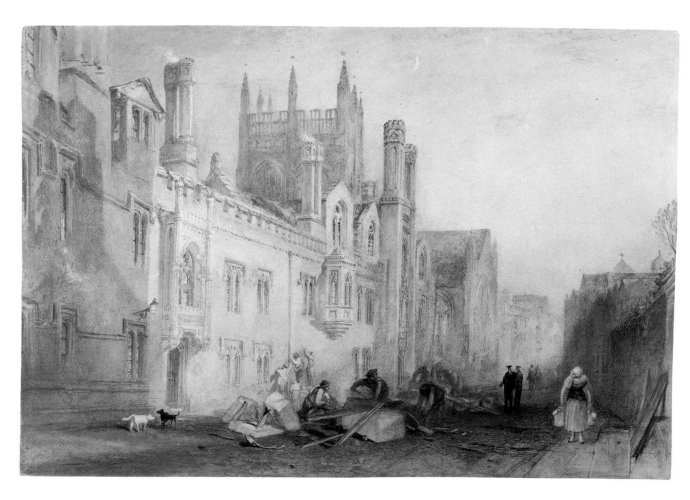

22 *Merton College*, 1838. Tate Gallery (cat. no. 55)

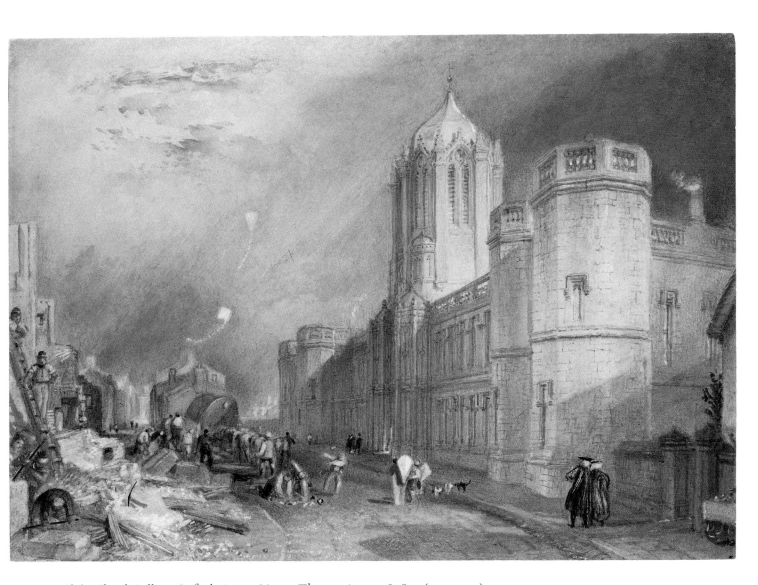

23  *Christ Church College, Oxford*, 1831–2. Messrs Thomas Agnew & Son (cat. no. 54)

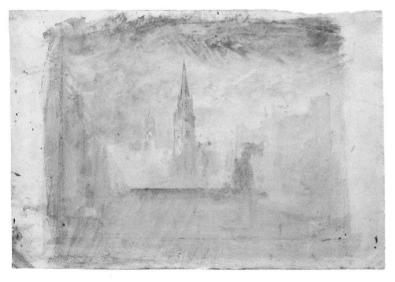

24 (ABOVE LEFT) *High Street, Oxford: Colour Beginning*, *c.* 1835–8. Tate Gallery (cat. no. 56)

25 (ABOVE) *High Street, Oxford: Colour Beginning*, *c.* 1835–8. Tate Gallery (cat. no. 57)

26 (LEFT) *High Street, Oxford: Colour Beginning*, *c.* 1835–8. Tate Gallery (cat. no. 58)

27 (RIGHT) *High Street, Oxford: Colour Beginning,* *c.* 1835–8. Tate Gallery (cat. no. 59)

28 (BELOW) *High Street, Oxford: Colour Beginning,* *c.* 1835–8. Tate Gallery (cat. no. 60)

29 (BELOW RIGHT) *High Street, Oxford: Colour Beginning,* *c.* 1835–8. Tate Gallery (cat. no. 61)

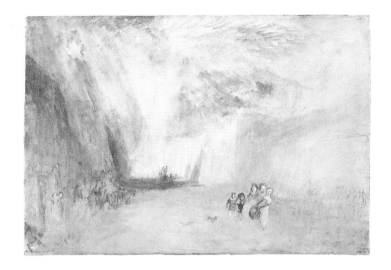

30 *Oxford from North Hinksey: Colour Beginning*, ?*c.* 1839. Tate Gallery (cat. no. 65)

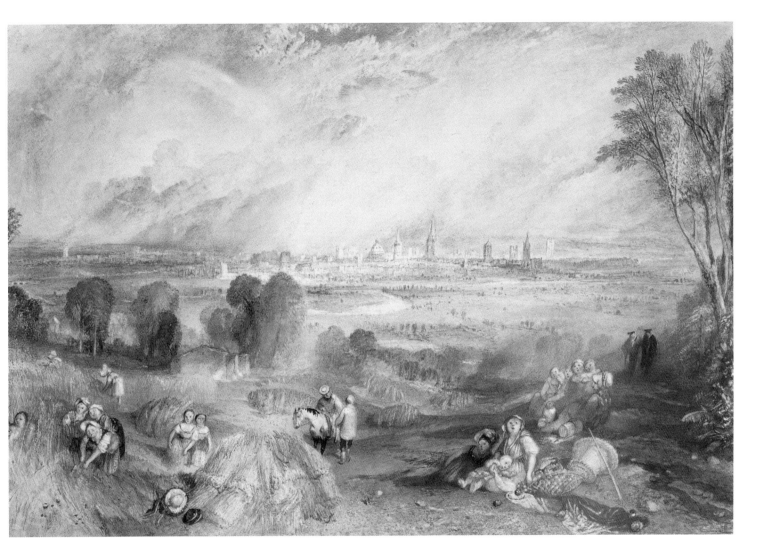

31 *Oxford from North Hinksey*, c. 1839. Manchester City Art Gallery (cat. no. 66)

32  *Garden of Trinity College: Colour Beginning*, c. 1835–8. Tate Gallery (cat. no. 62)

# 1

# Turner's Early Work at Oxford, to *c.* 1800

Since his own lifetime, Turner's early work has been neglected in favour of his later, apparently more 'personal' style, and his topographical watercolours regarded as little more than the prelude to a brilliant career spent disregarding the conventions they obeyed. In his division of Turner's life and work into decades, the artist's great champion, John Ruskin, dismissed the first twenty-five years as 'school days', the exhibition of the *Fifth Plague of Egypt* in 1800 marking the date when 'his established work and artist-power' began.[1] Yet, by this date, Turner was already twenty-five, had been exhibiting at the Royal Academy for ten years, and had received a number of important commissions. Indeed, he was a fully mature artist and capable of virtuoso technical feats, and free to accept or reject commissions as he wished.

Between 1787 and about 1804, Turner painted over thirty finished watercolours of Oxford subjects, by far the most numerous group devoted to a single place in his *œuvre*. Their progress illustrates both the technical expertise he acquired, and the sophistication he developed in presenting himself as the heir to the tradition of his seniors, Thomas Hearne, Michael 'Angelo' Rooker, and Paul Sandby, as well as his contemporaries, Edward Dayes, Thomas Girtin and others. The Oxford drawings are primarily but not exclusively of architectural subjects,[2] and reveal an interest not only in the late Gothic architecture for which the city was best known, but in buildings of all periods, with a special concentration on the work of Turner's patron, the architect James Wyatt, who may also have been another of his teachers. Unfortunately, even more than for the rest of his life, the work of this early period

is often impossible to document adequately, and the student is obliged to speculate on possible influences, the extent to which Turner knew the work of his predecessors recording Oxford architecture, and the friends and patrons he may have had within the university as well as among the townspeople. Answers, even tentative, to these questions should seek to explain why Turner produced so many depictions of Oxford in the first fifteen years of his career, as well as trace the development of his technique and stylistic affinities.

Joseph Mallord William Turner (fig. 2) was baptised on 14 May 1775 at St Paul's, Covent Garden;[3] he later

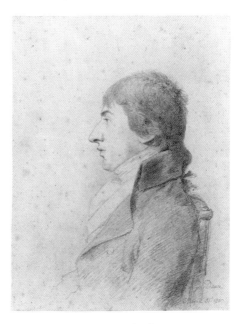

2 George Dance, *Portrait of J. M. W. Turner*, 1800. Royal Academy of Arts
(photo: Prudence Cuming Associates)

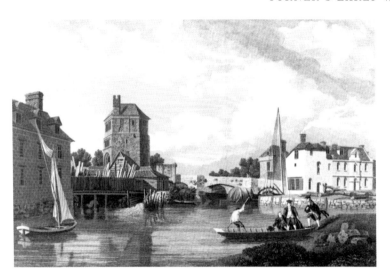

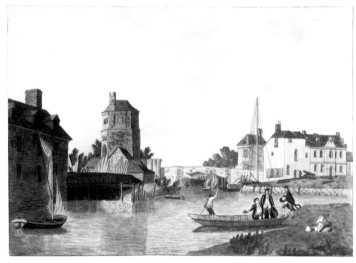

3 Michael 'Angelo' Rooker, *North West View of Friar Bacon's Study &c*, 1780. Ashmolean Museum

4 *North West View of Friar Bacon's Study &c*, 1787. Tate Gallery (cat. no. 1)

gave his date of birth as St George's Day, 23 April, but this seems improbable. His father, a barber, had left rural Devonshire some ten years earlier to seek his fortune in the capital, and had married his mother, Mary Marshall, at St Paul's, Covent Garden, on 29 August 1773. Both Turner's parents came from large families: William Turner was the third of seven children, and Mary Marshall the third of four. Her elder brother, Joseph Mallord William Marshall (1740–1820) was a butcher at Brentford, Middlesex, and the young Turner was sent to stay with him to recover from an illness in *c.* 1785; it was later reported to Joseph Farington that Marshall took care of Turner for three years.[4]

It was probably while he was staying with the Marshalls that he first came to Oxford, to visit other, more distant relations. Samuel Lovegrove, whose wife Sarah Haines was sister to Joseph Marshall's own wife, Mary, lived at Sunningwell, a small village on the Thames about four miles downstream from Oxford, working as a servant to the local vicar, the Revd Joseph Benet, who was 'in constant friendly intercourse with many principal persons' in the university.[5] The family connexion with Sunningwell continued until the 1830s,

and what may have begun as a convenient place of convalescence may equally have become a convenient stop on many of Turner's later tours. The Lovegroves remained in the village until their deaths, Sarah in 1822 and her husband ten years later. They were joined at Sunningwell by Joseph and Mary Marshall, who retired there at some time after 1798.[6] The whole family seem to have lived in the same house, which, according to a map Turner sent in 1822 to W. B. Cooke, was opposite the church, near the pond.[7] Joseph Marshall died in 1820, leaving his entire estate to his wife, who, on her death in 1826, made her nephew, J. M. W. Turner, a legacy of £200.

Turner's general education was in the hands of a succession of teachers, most prominently Sarah Trimmer, whose father, Joshua Kirby, was the author of the influential treatise on perspective, *Dr Brook Taylor's Method of Perspective made Easy* (1754). Turner was thus exposed at an early age to architectural drawing, and soon began to show a particular interest in this field. While at Brentford, he made his first extant work, colouring the engravings in Henry Boswell's *Picturesque Views of the Antiquities of England and Wales* in the copy belonging to a friend

of his uncle, John Lees, who paid him twopence per plate.[8] He also must have made many childish drawings of familiar subjects, but by the age of twelve, he was already making accomplished copies after prints by reputable artists. The earliest dated copy (fig. 4) is of a subject no doubt familiar to the boy, Folly Bridge, Oxford, copied after an unsigned print by Michael 'Angelo' Rooker published as the *Oxford Almanack* for 1780 (fig. 3).[9] The bridge straddled the Thames at the southern limit of Oxford, far outside the city wall, and had been a favourite with artists because of the eccentric octagonal structure of Friar Bacon's Study, the mediaeval gatehouse where the scientist and philosopher, Roger Bacon (1214–1294) was supposed to have had an observatory. S. H. Grimm drew it in c. 1776,[10] and Malchair many times before it was pulled down in 1779.[11] Rooker's *Almanack* was self-consciously picturesque, with individual elements of architecture and human activity crowded into a carefully orchestrated composition: barges and sailing boats, a handsome modern house at one end of the bridge and the mediæval folly and sawmill at the other, a woodman manœuvring large logs and gowned undergraduates being punted over the river in the foreground. The print offered a stiff test to the twelve-year old artist, and Turner acquitted himself well. His inability to conceive of the whole is characteristic of the child, but the components are carefully drawn, and he has triumphantly signed and dated his copy on the stones on the riverbank, *W. Turner 1787*. The colour, entirely imaginary, is crude and carefully applied.

There is a natural development from this copy to Turner's next view of Oxford, naïvely titled like a print in careful calligraphy, *A View of the CITY of OXFORD* (pl. 2). It probably dates from 1787–8, but was presumably taken from nature, on a hillside to the west of Oxford. Once again, each part is separately studied, and the buildings of the city crushed rather haphazardly into the hollow. Turner has at least succeeded in drawing the whole of the city, from St Giles' Church on the left (north) to Magdalen tower standing diminutive on the right.

Back in Brentford, Turner spent a brief period in the studio of the architect, Thomas Hardwick (1752–1829), a 'regular bred, classical architect',[12] whose son Philip became one of his friends and eventually an executor. Almost simultaneously, he began work in the studio of Thomas Malton the Younger (1748–1804), who offered him a consummate model of the kind of architectural view he had begun to experiment with. Malton's own drawings are hard and rigid, with rather plain colouring. However, he was especially successful in his aquatints, and his *Picturesque Tour through the Cities of London and Westminster*, which appeared in parts between 1792 and 1801, is generally regarded as one of the finest such collections ever made. When he sought election to the Royal Academy in 1795, he was rejected because he was 'only a draughtsman of buildings, but no architect'.[13] He was especially fond of low viewpoints and precise perspective, with buildings receding diagonally across the picture plane. These and other of his devices were adopted by his pupil, who incorporated them into his rapidly expanding repertoire of technical tricks.

In the summer of 1789, Turner again stayed at Sunningwell and took his first sketchbook on his first sketching tour; he was fourteen. The aims were modest: to record the appearance of the notable landmarks around Sunningwell and in the village itself. The most remarkable of these sketches are those of Sunningwell Church, Radley Hall, and the house and park at Nuneham, described by Horace Walpole in 1780 as the most beautiful landscape in the world, and which gave a Claudean view of Oxford from its terrace, as Farington and others drew at this time. One of Turner's drawings of Nuneham is annotated *Tuscan Ionic*, and the classical columns are also listed on the last leaf. In this book, Turner also took the opportunity to sketch the view of Oxford from the hills to the south. From the map of 1820 mentioned above, we can

trace his route to the vantage point, which did not follow the main road from Sunningwell to Oxford, but cut across country to the top of Boar's Hill, and down the footpath past Chilswell Farm.[14] He later worked this up into a finished watercolour, the first example of what was to become the norm in his creative process.

The resulting *Distant View of Oxford from the Abingdon Road* (fig. 5) shows the rapid advance Turner had made since his previous panorama a year or two earlier. The sketch includes annotations such as 'barley', translated into orange and brown, with simple blue and green for the sky and trees. The architecture shows much greater control in drawing, and a more confident sense of space in its arrangement. The topography is also extremely accurate. The technique, of using a fine pen to outline the buildings and trees, is slightly reminiscent of Paul Sandby, whose work Turner may have seen locally or in London.

The same character is evident in a similar watercolour (pl. 1), which has recently emerged from a succession of private collections. This distant view of Oxford is enlivened by a boy and a bounding dog, with a flock of sheep, and the foreground is dominated by a strong stand of trees, placed slightly off-centre. Turner gave the watercolour to the daughter of one of his father's friends, Miss Narraway, at much the same time as he gave her father his first exhibit at the Royal Academy, *The Archbishop's Palace, Lambeth*.

It is Miss Narraway's cousin, Ann Dart, who gives the most vivid portrait of Turner at this awkward age. In a letter to Ruskin written in her old age, she remembered that he was

*not like young people in general, he was singular and very silent, seemed exclusively devoted to drawing, would not*

5 *Distant View of Oxford from the Abingdon Road*, 1789. Tate Gallery (cat. no. 3)

6 Michael 'Angelo' Rooker, *Broad Walk*, *Christ Church*: the *Oxford Almanack* for 1776. Ashmolean Museum

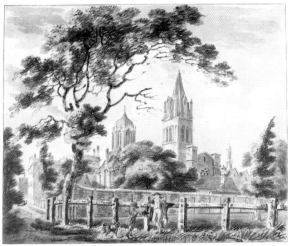

7 *Christ Church from Merton Fields*, *c.* 1790–91. Tate Gallery (cat. no. 6)

*go into society, did not like 'plays', and ... had no talent for music.... He had no faculty for friendship and though so often entertained by my uncle he would never write him a letter.... My uncle indeed thought Turner some-what mean and ungrateful.*[15]

Yet he was happy to give away drawings to his hosts at Bristol, not only those he had made while staying there, but seemingly the Oxford drawing he had presumably made in London or Sunning-well.

On Hardwick's advice, Turner applied to study at the Royal Academy Schools, and was admitted in 1789. The teaching would have concentrated on life drawing and copies after the Old Masters, and records show that Turner attended classes once or twice a week, and was a diligent student. He also heard Sir Joshua Reynolds's last discourse as President, in which he extolled the supremacy of Michelangelo, whom contemporaries generally considered less appropriate as a model than his more classical and decorous rival, Raphael. The immediate result of the beginning of Turner's artistic education was that, when the annual exhibition of the Royal Academy opened in April 1790, it included a

watercolour by the fourteen-year old artist, *The Archbishop's Palace, Lambeth*, which he later gave to John Narraway.[16]

Turner's first drawing of Oxford buildings (fig. 7) applied the lessons of Malton – low viewpoint and diagonal perspective – to a view he may already have known from Rooker's *Almanack* for 1776 (fig. 6). The differences between Rooker's work and Turner's are, however, significant: the subject of Rooker's view is really the Broad Walk, a popular spot for strolling in Christ Church Meadows, bordered on one side by trees and on the other by the gardens of Christ Church, the cathedral, and Fell's Building. Turner, on the other hand, shifts the emphasis completely, so that the vanishing vista is subordinate to the depiction of the spire of the cathedral and its juxtaposition with Tom Tower, the two motifs of Oxford architecture he was to draw most frequently in the next ten years. The contrast between the rigidly geometrical spire and the organic and fluent form of the tower are carefully emphasised, to the detriment of the perspective. The foreground is animated with figures and a contrasting rustic fence (Rooker's is clearly a very elegant park fence). Turner's watercolour is a brave attempt at a

difficult subject, and one that he would try again twelve years later.

In 1792, Turner set off on his first extended sketching tour, up the Wye Valley as far as the Devil's Bridge. It is generally assumed that he stopped at Oxford or Sunningwell at the beginning or end of the tour, making several pencil drawings which he later worked up into watercolours.[17] Unfortunately, the convenience of the chronology is merely coincidental, and it is not possible to date Turner's visits to Oxford in the 1790s: the city was easily accessibly from London and Brentford, and Turner may have passed through it on almost any of his journeys north or west. As Benedict Nicolson wisely wrote in another context, the artist 'does not have to document every journey … for the historian's benefit',[18] and the number of studies and sketches, especially from the 1790s, that Turner did not preserve for posterity ensure that his movements are not as fully recorded as might at first appear. Indeed, the only visit to Oxford which can be securely dated was the first, from a sketching expedition in the surrounding countryside which may not have taken him into the city at all.

Moreover, it is regrettably possible only to speculate as to who Turner might have known at Oxford, although it is certain that he had friends among the senior members of the University in the 1790s. A letter to the local artist, William Delamotte, postmarked 1800, gives several clues.[19] First, Delamotte himself, Turner's exact contemporary, whom he must have known at the Royal Academy Schools, and who had probably settled at Oxford by the time Turner came in 1795–6.[20] He was, in any case, the recipient of a handsome watercolour of *Iffley Mill* in 1800, which perhaps recorded a sketching trip together, and which may have prompted a reciprocal gift from Delamotte.[21]

The second, and more tantalising, name in this letter is that of 'Dr Jackson', whose identity can only be surmised. The more probable candidate is Cyril Jackson (1746–1819), an inspiring figure who has been described as having a 'genius for government'

rare among Oxford dons.[22] After being consecrated a Canon of Christ Church in 1779, he was appointed Dean in 1783. Despite several offers of preferment, he remained in his old college until his retirement in 1809, and was a strong influence on generations of undergraduates, many of whom he befriended, and an *eminence grise* behind the throne and several politicians, such as Peel and Canning. Among his interests was architecture: he took undergraduates on walking tours during the long vacation, and was instrumental in various architectural improvements in his college, such as the regothicization of the hall in 1800–04. He would seem to have been a natural companion to a young architectural draughtsman, and was also a Delegate of the Clarendon Press, the only member of this body it has been possible to connect with the young Turner. The less likely candidate for Turner's 'Dr Jackson' was Cyril's brother, William Jackson (1751–1815), who followed him to Christ Church, whence he matriculated in 1768, and continued through the same cursus of degrees, before being admitted D.D. in 1799. He was consecrated Bishop of Oxford in 1812 after Cyril had declined the honour. The interest of one or other of the Jackson brothers in drawing is recorded in the inscription on a study of Christ Church Cathedral from Fell's Building by Malchair in 1778; unfortunately, both brothers were in residence at this time.[23]

The final name in this letter to Delamotte is that of 'Mr Williams', a printseller with whom Turner had dealings, buying rather than selling, according to a memorandum in the 'Rhine, Strassburg and Oxford' sketchbook of 1802.[24] He may also have provided an outlet for Turner's watercolours of Oxford not commissioned by specific patrons.

It is especially regrettable that we cannot identify conclusively Turner's friends at Oxford, for his interest in the architecture, or his easy access to the city from Sunningwell or London, cannot in themselves explain the large number of drawings he made in the 1790s. Nor can his choice of subjects be explained simply by making the obvious statement that 'Magdalen and

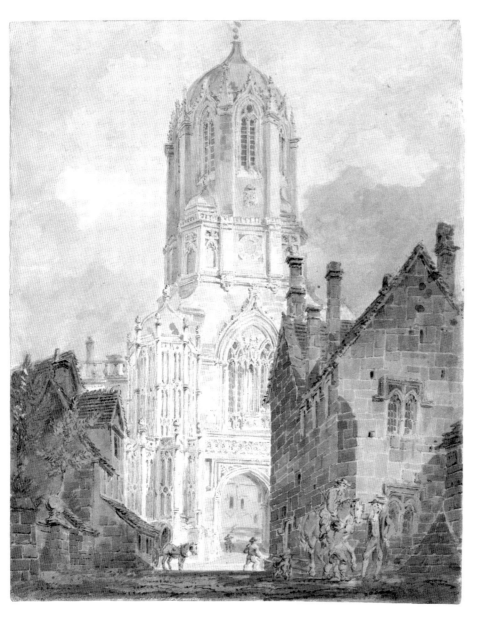

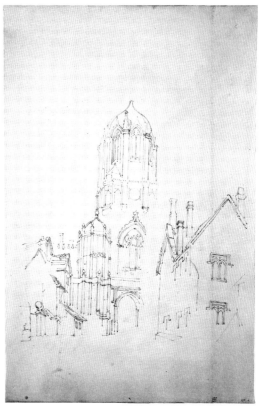

Christ Church ... were frequently singled out in the
art and literature of the period as the "pride of
Oxford'".[25] Somebody, quite possibly Dr Jackson,
enabled him to draw in the private gardens at Christ
Church, not once, but over several years, and helped
him obtain numerous commissions.

The first of these were two contrasting watercolours
of architectural subjects, the front gate and the view
from the back gate at Christ Church (pl. 3). *Tom Tower*
(fig. 8) shows Sir Christopher Wren's design for the
completion of Wolsey's gateway to the college, which
had remained unfinished for over a hundred years.
Wren continued the Gothic manner of the gatehouse,
but simplified it and added an ogee shaped dome. From
a distance, the base could not be seen, but from the
opposite side of St Aldate's, it was framed by a rather
haphazard arrangement of houses and St Aldate's
church. It offered several possibilities to the artist:
Malchair, for example, had emphasised the confusion
and the impossibility of gaining a logical viewpoint, in

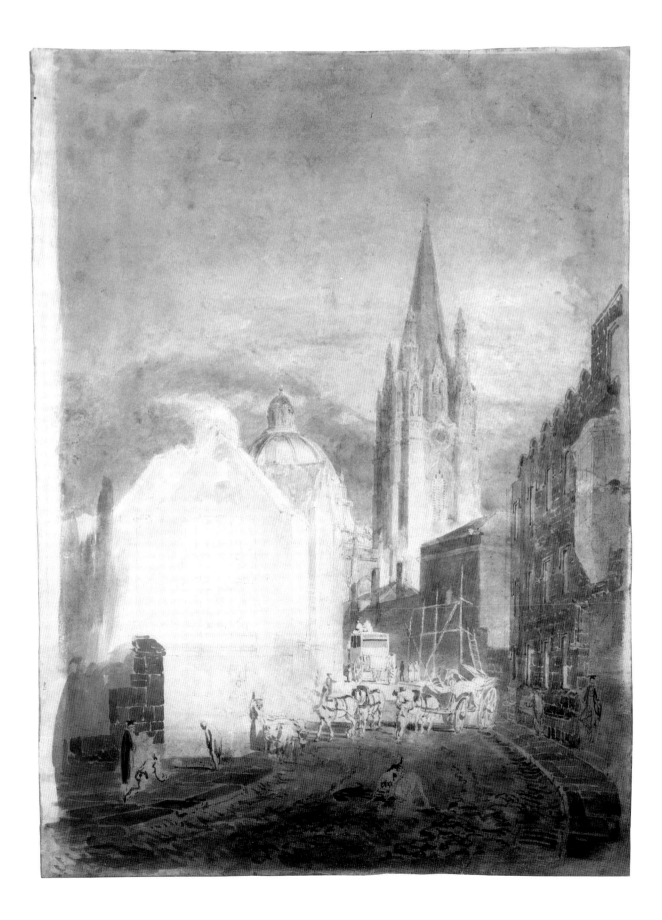

keeping with his preference for nostalgic mediævalism.[26] Turner, however, preferred to create order and contrast from the scene. He made two watercolours, one signed and presumably earlier,[27] the other slightly smaller, repeating essential details exactly, even to the time on the clock, but with more lively figures – instead of the single undergraduate absorbed in reading, there is a group of a rider on horseback talking to an undergraduate or servitor, and even the figures taken directly from the earlier watercolour are more amusing, with bulging forms which would not have been out of place in Rowlandson's Oxford. In an unusual experiment (fig. 9), Turner traced over the main lines of this drawing, moving the paper between the right and left halves, so that a much wider space emerged between them and the composition was much less tighly packed. This came to nothing, but demonstrates the liberties Turner allowed himself with topography even at this early date, and the restlessly experimental nature of his work.[28]

A similarly elaborate arrangement of architectural styles and motifs could be found at the opposite end of Christ Church, in the triangular space bounded on the east by Oriel College, on the west by Canterbury Gate and the Provost of Oriel's stable, and on the north by domestic architecture (pl. 3). Dominating the arrangement is the spire of the University Church of St Mary the Virgin, wearing an elaborate collar of several rows of pinnacles, and the most exuberant example of Decorated Gothic in Oxford. In his first watercolour of this scene, Turner continued the light-hearted colouring and jaunty figures of *Tom Tower*, the waggon, man on horseback and dogs closely related to their counterparts in the companion watercolour. The perspective is still rather unsteady, and several of the buildings near to toppling over and in awkward relation to each other, but the manipulation of the receding street is already handled with skill.

10 (LEFT) *St Mary's Church and the Radcliffe Camera from Oriel Lane*, c. 1795. Tate Gallery (cat. no. 9)

A larger and later version of the same scene (fig. 10) is much more controlled, and includes for the first time the scaffolding that Turner was to include so frequently in his views of Oxford. While this may have had some symbolic meaning related to the development of a young man's mind, it was also practical, since the soft stone quarried at Headington and further afield from which most Oxford buildings were constructed was extremely friable, and the city thus became a constant building site. This watercolour remained unfinished, and is revealing of Turner's working method of c. 1795, drawing in the outlines carefully in pencil before colouring and adding details in pen and ink. It is not clear why he should have abandoned the work in its present state, with the sky fully coloured and the houses blank. It may have been for some mundanely practical reason, for example the lack of a particular colour.

## Works for Monro and Henderson

The doubts over Turner's chronology in the early 1790s extend to his relationship with two collectors for whom he worked extensively, both of whom owned Oxford drawings: Dr Thomas Monro, and John Henderson. Dr Thomas Monro (1759–1833)[29] was an alienist and principal physician to Bethlehem Hospital. He attended John Robert Cozens in his final illness, and acquired a great many of his works, as well as drawings and prints by other artists, both Old Master and contemporary. In 1794, he took a furnished house at 8 Adelphi Terrace, and on 30 December that year, Farington recorded that 'Dr Munros house is like an Academy in an evening. He has young men employed in tracing outlines made by his friends &c. – Henderson, Hearne &c. lend him their outlines for this purpose.'[30] Among the 'young men' were Dayes, Girtin and Turner. Four years later, Farington met Girtin and Turner at a dinner party, and they 'told us they had been employed by Dr. Monro 3 years to draw at his house in the evenings. They went at 6 and staid

til Ten.... They were chiefly employed in copying the outlines or unfinished drawings of Cozens &c &c of which Copies they made finished drawings. Dr. Monro allowed Turner 3s. 6d. each night.'[31] From Farington's evidence, it would seem that Turner worked for Dr Monro between 1794 and 1797, but he certainly knew him in 1793, when he drew his country property in Hertfordshire, and there is nothing to preclude the possibility that Monro had begun his 'academy' at his previous address in Bedford Square.

Monro's near neighbour in the Adelphi was John Henderson, another ardent collector and amateur artist. Both Monro and Henderson owned drawings by Canaletto, and it is reasonable to conjecture that it was from their evenings at the Adelphi that Girtin and Turner became familiar with his characteristically mannered style of hooks, dots, and broken lines (although they may have learnt it from Farington, who also practised a rather more fluent and debased

version of it). The matter of dating is important because Turner's watercolours of Oxford buildings for Monro and Henderson date from 1794, and the preliminary sketch for one of them is generally dated to 1792. There is, of course, no reason why Turner should not have waited over a year before working up a sketch, but his energy and ambition would seem to suggest that the sketches were made later, in 1793.

Turner's first and notoriously unreliable biographer, Walter Thornbury, tells us that 'one of his earliest tours was that made to Oxford to execute drawing commissions for his kind patron, Mr. Henderson.'[32] These drawings may be the small group of Oxford subjects in the laborious Canaletto manner now mostly in the Turner Bequest. They are all of similar size and represent a real campaign of sketching. The first (fig. 11), *The Radcliffe Camera*, is an eccentric view of the most distinctive Baroque building in Oxford, seen from the garden of Brasenose College, whose crenellated wall blocks the view. Another (fig. 12), less successful, is of the East End of Merton College, an

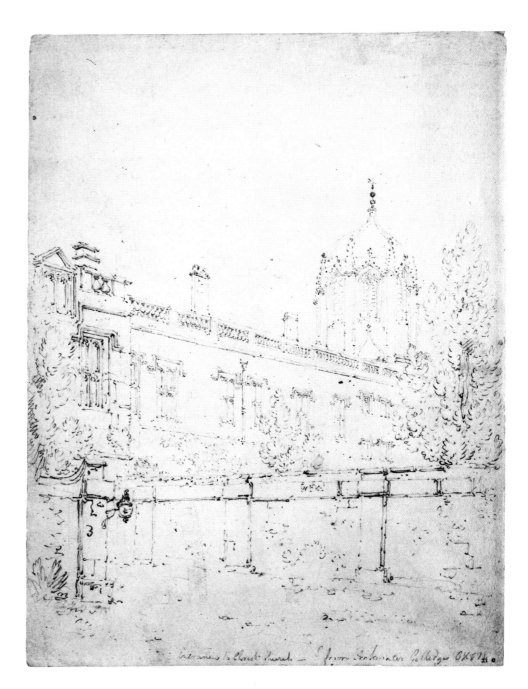

attempt to integrate the east end of the fourteenth-century church and the garden in flourishes of pencil which results in confusion. The third (fig. 13), the narrow passage between Fell's Tower and the Canons' gardens at Christ Church, includes a similar compositional device cutting off the lower part of a celebrated monument with a more banal horizontal element,

but achieves greater clarity of texture and design.

The only drawing of this group that succeeds in its aims is *Magdalen Tower and Bridge, Oxford*, which is also the only one Turner developed into a watercolour. The tower itself is Oxford's most celebrated landmark. Originally constructed at the end of the fifteenth century, it stands at the eastern entrance to the city, at

the end of the elegant new bridge of six arches over the Cherwell built to the designs of John Gwynne in 1772–90. The bridge was generally drawn from the prosaic entrance from the London Road, as Malton was later to do in his aquatint of 1802. In 1794, Dayes drew it for the *Oxford Almanack* from the banks of the Cherwell, incorporating the whole bridge and tower into a general townscape set on a lush riverside plain (fig. 14). Turner preferred a more closely observed view (fig. 15) of only three arches of the bridge and the tower soaring above. He used a similar arrangement in a view of *Old London Bridge, with St Magnus the Martyr and the Monument* of c.1795.[33]

The drawing of Magdalen Bridge was worked up into two watercolours, one for Dr Monro, the other for Henderson (pl. 5, fig. 16). From the crisper penwork and greater spontaneity in the washes, it is clear that Monro's was the first, but they are otherwise identical. Even the figures are the same – a punt emerges from under the bridge, carrying a fisherman sitting in an armchair, while on the opposite bank a lad waters a horse, and another leaves the river carrying water in paniers. Perhaps the second version was made for an envious Henderson at Dr Monro's 'Academy' one evening.

A second drawing for Henderson is the most impressive of the stylistically similar works of late 1794. *Christ Church from the South* (pl. 7) incorporates the arrangement of Tom Tower cut off by the horizontal block of the south range, with balustrade, and the western portion of the hall. The plain geometrical composition is disturbed by the buildings in the foreground on the banks of Trill Mill stream, creating a picturesque assemblage of the monumental and the vernacular Turner was also painting in many cathedral cities at this time. The figures – a covered waggon coming towards us and a gowned don walking away – are smaller and less obtrusive, and sensitively integrated into the composition. Still at Christ Church, he painted a view of the cathedral from the garden (pl. 8). Its early provenance is not known, and the

fact that it is signed and dated might indicate that it was made for sale. It is most notable for the great freedom in the painting of the trees, quite different from the short dabs Turner used in other works of the same year.

Another of the very finely drawn watercolours from the same period shows the *Founder's Tower, Magdalen College* (pl. 6). The subject was unusual, in spite of its importance to the college. For it marked the original entrance, as planned by the founder, William of Waynflete, and is as exuberant and imaginative as any late Gothic architecture at Oxford. Once again, Turner chose an oblique angle of perspective, and very low point of view, to create the most monumental of his watercolours of Oxford in 1794.

The final watercolour from these years is another view of Christ Church, *Christ Church Cathedral from the Canons' Garden*, which was made about a year later, and engraved in aquatint by R. G. Reeve in 1807 (pl. 9). It is likely that Reeve obtained it and the three other watercolours by Turner he published at this time directly from the artist, the others being *Clare Hall, Cambridge*, *Malmesbury Abbey*, and *Peterborough Cathedral*.[34] Christ Church Cathedral is this time seen from the north, with the deanery on the left, and the 'open arms' of the perspective more exaggerated than ever. This work may have been made for Dean Jackson.

Turner's activity between 1795 and 1800 was enormous, his commissions steadily increasing and his range of subject matter and technical experiments ever bolder. One of the new associates who had a direct bearing on his work at Oxford was the architect, James Wyatt. Turner may have been introduced to him by Sir Richard Colt Hoare, and the number of his buildings Turner drew in the late 1790s attests to an unusual admiration for his work. At the Royal Academy in 1798, Turner exhibited under Wyatt's name a *Northwest View of Fonthill Abbey*, and he continued to work for Wyatt and his patron, William Beckford, at Fonthill for some time, showing five large watercolours of the

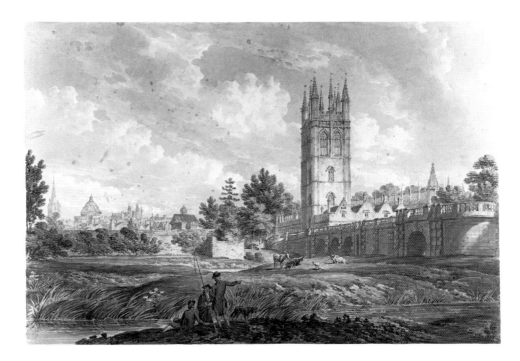

14 (RIGHT) Edward Dayes,
*Magdalen Tower and Bridge*,
1794. Ashmolean Museum

15 (BELOW) *Magdalen Tower
and Bridge, Oxford, c.* 1793.
Tate Gallery (cat. no. 13)

16 (BELOW RIGHT)
*Magdalen Tower and Bridge,
Oxford, c.* 1794.
British Museum (cat. no. 15)

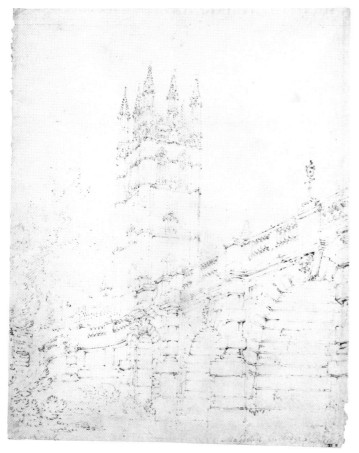

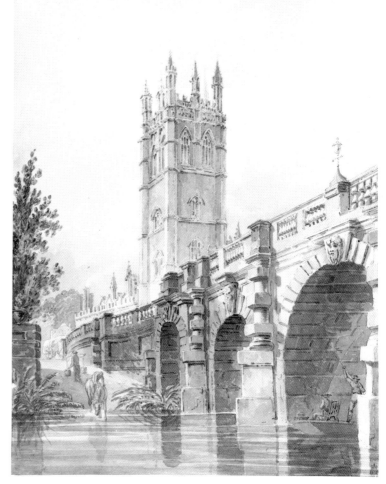

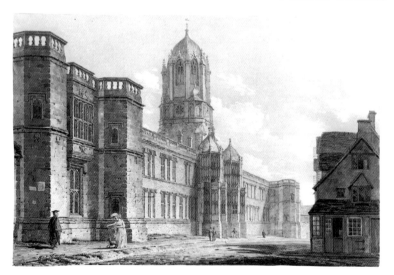

abbey at the Royal Academy in 1800. Wyatt's work in Oxford was extensive, and, although Turner did not draw all his projects, the preponderance of buildings designed or altered by Wyatt that he did draw attests to a renewed interest in contemporary architectural practices.

17 (LEFT) Edward Dayes, *Christ Church from near Carfax*, 1794. Ashmolean Museum

18 (BELOW) *Christ Church from near Carfax*, c. 1796. National Gallery of Canada, Ottawa (cat. no. 20)

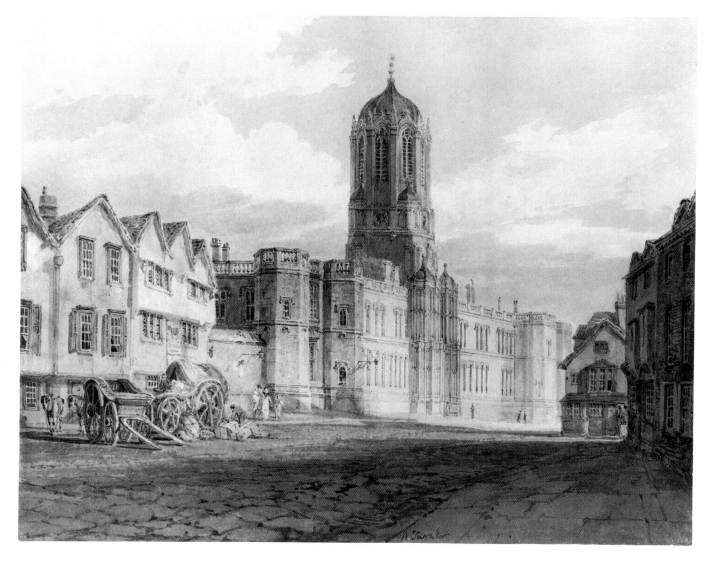

## Four Watercolours for Lord Mansfield

Another patron from Turner's time at Oxford was William Murray, Viscount Stormont (1777–1840), the great nephew of the redoutable Lord Chancellor, the first Earl of Mansfield. The family lived at Kenwood House on Hampstead Heath, and are not otherwise known as patrons of Turner. Lord Stormont went up as a nobleman commoner to Christ Church in 1794, and had a suitably grand set of rooms on the south side of Canterbury Quad. He paid his caution on 9 June 1794, and his tutor was the young William Carey, later Bishop of Exeter. He was also exactly the class of undergraduate cultivated by the Dean, Dr Jackson. Stormont was repaid his caution money on 29 June 1796, and succeeded as head of the family on the death of his father on 1 September. As the third Earl of Mansfield, he divided his life between his family's Scottish seat at Scone Palace, where he commissioned the Gothicization of the interior by James Wyatt's pupil, William Atkinson,[35] and Kenwood, where he also ordered Atkinson to undertake the wholesale redecoration of the interiors. Mansfield was not a notable patron of modern painting, although he reluctantly launched Wilkie's career by buying *The Village Politicians* at the Royal Academy in 1806.[36] The four watercolours of Christ Church by Turner that he owned must be among the most interesting and enlightened examples of undergraduate souvenirs. All are of similar size, although they were probably not all completed, or even planned, before Mansfield went down in 1796.

Unusually, preparatory studies survive for three of the drawings, and related watercolours for two. The most imposing is a grand view of the west front of Christ Church facing onto St Aldate's, carefully signed and probably the first to be drawn. Whether it was commissioned or merely bought by Lord Mansfield is impossible to tell. It was preceded by an unfinished sketch in sharp pencil outlines partly finished in sombre tones of grey-green and brown watercolours, in the 'South Wales' sketchbook,[37] made at the beginning or end of the tour to Wales in the summer of 1795. The view is similar to that taken the previous summer by Edward Dayes (fig. 17),[38] which Turner must surely have seen. Characteristically, the younger artist includes not simply the monumental west front of the college, seen at an oblique angle and balanced by one house on the opposite side of St Aldates, but two and a half picturesque houses to the left of Christ Church, including the Bull Inn, complete with carrier's waggons being loaded. On the opposite side of St Aldate's, considerably wider than in reality or in Dayes's depiction, we see more of the picturesque houses, irregular and slightly ramshackle, to which Turner was attracted in Oxford. Since many of the studies in his sketchbook were never worked up into finished watercolours, it is tempting to speculate that the young Lord Stormont may have commissioned his watercolour (fig. 18) after seeing Turner's sketch. Alternatively, he may simply have ordered a repetition of Dayes's almanack.

The second of this group of watercolours shows the entrance to Canterbury Quad (fig. 19), where Stormont had rooms. It was constructed to the designs

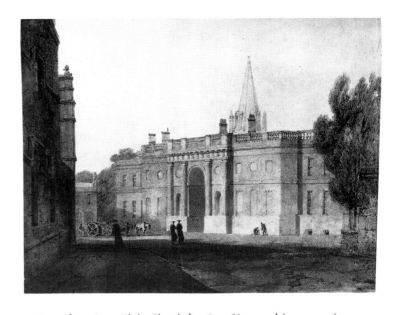

19 *Canterbury Gate, Christ Church, ?c.* 1800. Untraced (cat. no. 21)

20 (ABOVE) *Tom Tower from the Canons'
Garden*, ?*c*. 1799–1800. Tate Gallery
(cat. no. 23)

21 (RIGHT) *Tom Tower from the Canons'
Garden*, ?*c*. 1799–1800. Private collection
(cat. no. 24)

of James Wyatt at the expense of Richard Robinson, Bishop of Armagh, for the exclusive use of gentlemen commoners and noblemen. The triumphal arch marking its entrance made the best of an awkward position at the end of King (now Merton) Street, where, far from closing the vista, it was largely invisible; and at the south west corner of the unevenly shaped 'square' in front of Oriel College. It was no more satisfactory from inside the college, masked by the extravagant giant Corinthian order of the library in the adjoining and grandiose Peckwater Quad. However, as an architectural set piece and disregarding its setting, it could not have been more imposing, with its blank alcoves and baseless Doric columns in mellow yellow stone.

Its position and surroundings did not make it easy to draw, and few artists had attempted it. Turner had two reasons to do so: the first, simply that it was, so to speak, Mansfield's front door; the second, that it was yet another of Wyatt's projects in Oxford, and a distinctive contribution to modern architecture, at least in England. He made a preliminary scribble in pencil laying out the arrangement and spacing of the niches,[39] and a fully resolved and detailed watercolour of the whole monument, complete with the spire of the cathedral cheekily visible behind it. This work again invites comparison with one of Rooker's *Almanacks,* that for 1781, which is much less exaggerated in perspective and more strait-laced in effect.

The two remaining watercolours owned by Lord Mansfield seem to have been made after he left Oxford, and on stylistic grounds, as well as in the topicality of one of the subjects, date from *c.* 1799–1800. The two preparatory drawings are in similarly vigorous style and on identical sheets of paper (figs. 20, 22). One shows Tom Tower, by now so familiar to Turner, from the Canons' Garden, with the range of the north-east

canonries between. It is not an obviously picturesque view, and may have been chosen to show the canonry itself, which was apparently occupied by the canons of the first and eighth stalls, Thomas Hay and James

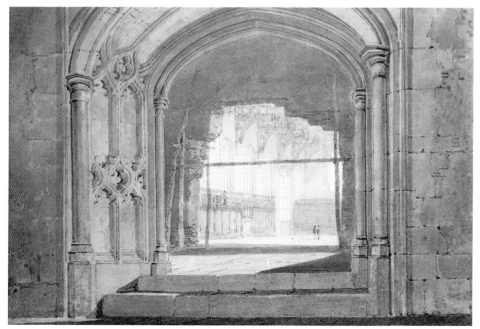

22 (ABOVE) *Christ Church Hall from the Staircase, c.* 1799–1800. Tate Gallery (cat. no. 25)

23 (LEFT) *Christ Church Hall from the Staircase, c.* 1799–1800. Leeds City Art Galleries (cat. no. 26)

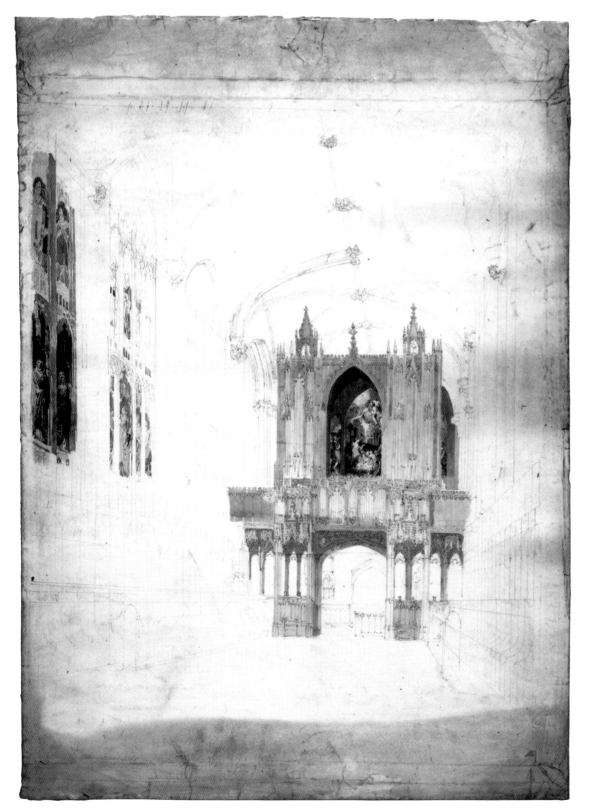

24 (LEFT) *Interior of
New College Chapel,
looking through the
organ screen towards
Reynolds's west window,
c. 1798–1800.* Tate
Gallery (cat. no. 28)

25 (RIGHT) *Interior of
New College Chapel,
looking East, c. 1798–
1800.* Tate Gallery
(cat. no. 27)

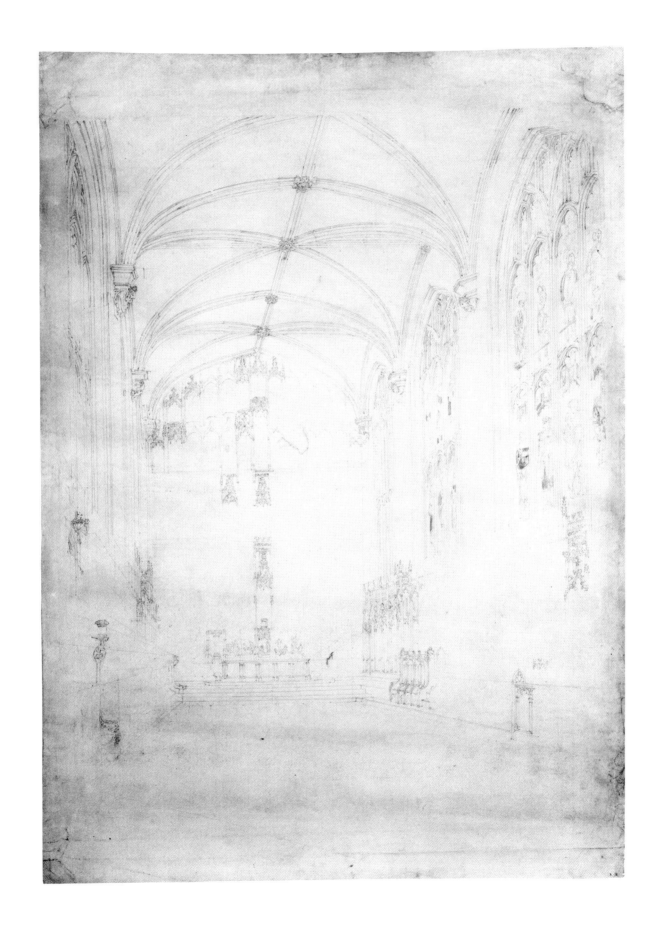

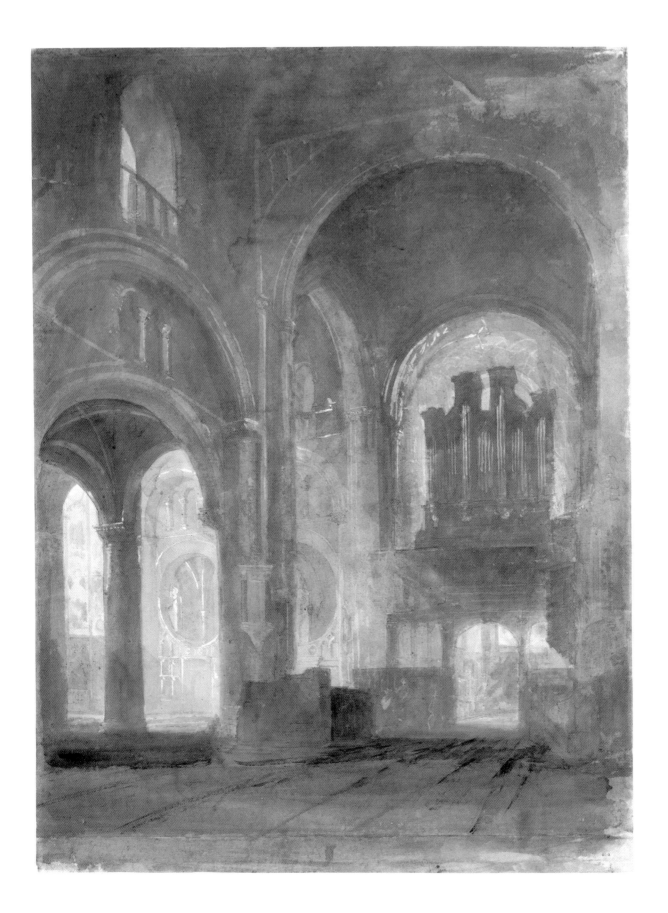

Burton, neither of whom had any obvious connexion with either Turner or Mansfield.[40] The watercolour (fig. 21), although somewhat faded, shows great precision in describing the pinnacles of Tom Tower, and the balustrade atop the canonry, and contrasts very strongly with the newly found freedom in drawing the trees in the Canons' garden.

The last of this group, *Christ Church Hall from the Staircase* (fig. 23), shows one of the most intractable problems in Oxford architecture, the appearance of the staircase before Wyatt's renovations. Turner's preparatory drawing (fig. 22) shows more clearly than the watercolour the very temporary arrangement of scaffolding around the doorway, and the ragged edge of the doorway itself as it was enlarged. The appearance must be connected with a receipt or valuation from Wyatt for wainscoting and columns, preparatory to the sweeping away of the Georgian fittings in the hall and their reinstallation as Wyattized Gothic in 1799–1800.[41] Apart from Turner's own interest in the temporary and the topical, the watercolour, in rather sombre monochrome of brown, perhaps expressed Mansfield's incipient interest in the gothicizing he was shortly to begin at Scone. The narrow focus on the doorway and scaffolding contrasts strongly with the view of the same subject, of perhaps a year or two later, by Thomas Malton, which conventionally shows the whole staircase, and a grille between the staircase and the hall itself.[42]

## Experimental Drawings

This account of Turner's work in Oxford has necessarily concentrated on his public commissions, most for particular patrons and none therefore made specifically for exhibition. Parallel with this work, Turner was restlessly experimenting, particularly in applying some of the principles of oil painting to his watercolours. His tours became more extensive, and he sought new subjects and new means of expression.

Towards the end of the 1790s, Turner made a series of large perspective drawings of architectural interiors, experimenting with techniques and media. Some of these were developed into finished watercolours exhibited at the Royal Academy, such as the drawings of Fonthill Abbey already mentioned, while the great majority remained unresolved. It is not unexpected that the buildings of Oxford should have provided three large drawings of this type, and two rather different watercolours for the *Oxford Almanack* (see the next chapter).

New College Chapel was a natural choice for two of the unfinished works. Its sheer size encouraged feelings of the sublime, and its recent history provided numerous associations for the young Turner. The original plan, laid out by the founder of New College, William of Wykeham, on the plan of Merton College, provided an antechapel and main chapel, separated by a screen. In 1789, James Wyatt was commissioned to restore the interior in the current Gothic taste, sweeping away many of the alterations to the original interior, such as uncovering the reredos behind the altar, inserting a plaster ribbed roof, and constructing a new organ screen between the ante-chapel and chancel. The most dramatic, almost melodramatic, device was to insert a pointed arch in the screen to frame the newly painted west window. The window itself, painted between 1778 and 1785 by Thomas Jervais to designs by Sir Joshua Reynolds, is the most beautiful work of the century in Oxford, paying sophisticated court to Correggio's *La Notte* in suitably luminous colours.

Turner's drawings (figs. 24, 25) of this magnificent interior may therefore be a homage to Reynolds, his first mentor at the Royal Academy and the man whose ideal of history painting he never forgot; and to Wyatt, who had by this date engaged Turner to paint the fantastic and ill-fated tower at Fonthill. In the view

26 (LEFT) *Interior of Christ Church Cathedral, looking past the Crossing and Organ Screen into the Chancel, c.* 1798–1800. Tate Gallery (cat. no. 29)

looking west, the architecture is drawn in spare and ruled pencil lines, with details of the roof bosses and one or two capitals, and only Wyatt's screen and the west and south windows shown fully. These areas are also coloured in watercolour, minutely for the glass, and broadly for the screen, reflecting the function of the drawing in conveying detailed information about these parts. The other drawing completes the exploration, looking east towards the reredos, which is indicated in Turner's characteristic shorthand, one element – stall, niche, or tracery in a window – serving to indicate the remainder. Both drawings are made on immense sheets of paper, which would have been pinned to a drawing board – the paper is still folded round the edges and the pinholes still visible.

The third of these drawings (fig. 26) shows the interior of Christ Church Cathedral, which Turner had so often drawn from the outside. Here, Turner's interest lay not in mediæval details (such as the spectacular vault) or stained glass, but in the soaring arches and graceful play of space between the nave and transept. Broadly applied washes are defined in white body-colour and much scratching out, but the vigorously drawn floor betrays the eccentricities of perspective and the colouring lacks unity.

Two further drawings from *c.* 1799 may be associated with these experiments, one, of *Canterbury Gate, Christ Church* (pl. 11), the other of *Christ Church from the Isis* (pl. 10). The former is a broadly washed variant of the view for Lord Mansfield, but the two tiny figures dabbed in evoke a feeling of the sublime far removed from the reality of Wyatt's architecture. The second, roughly contemporary, sets Christ Church on the riverbank, the whole intensely personal and poetic, and closely related to several pencil drawings, as well as to the first of Turner's *Almanack* drawings.

The University may have occupied most of Turner's attention during the 1790s while visiting Oxford, but he was never a member, and, unlike the contemporary topographical artist, John Britton, never seems to

have hankered after the respectability it offered;[43] he knew that the position of R.A. would entitle him to the designation 'Esquire', which he used proudly when he achieved the dignity. The remaining works produced at this time all depict rather the town than the gown.

*Folly Bridge, Oxford* (pl. 4, fig. 27) may go back as far as 1793–4, and resumes the view Turner had copied from Rooker's *Almanack*. The main difference is the absence of Friar Bacon's Study, which Turner had probably never seen in reality. Like Rooker, he includes the numerous activities associated with this stretch of the river – boats and barges under tarpaulin, a cart leaving the quayside, and a coach going to Abingdon across the bridge. An unfinished copy of the drawing (fig. 28) demonstrates once again that Turner's industriousness in copying included his own work as well as that of other artists. It probably dates from the same time as a pencil study of Folly Bridge from the opposite direction (fig. 29).

The main streets of Oxford provided material for several pencil studies in *c.* 1798–9. Two views up the High Street from All Souls' College towards Carfax later served as the basis for an oil painting (see cat. no. 51a), but one records the Cornmarket, the main thoroughfare running from north to south in Oxford. Each building on the east side of the street is carefully depicted, from the present Market Street down towards Carfax, with the ghostly form of Tom Tower in the distance. Turner has made various notes of 'Randell's Hat Manufacturer', and 'Turner Drawing Merchants', and carefully marked the Roe Buck Inn. Typically, and far more than in the roughly contemporary views of the High Street, he has created a majestic avenue out of the rather narrow and crowded street, and, by omitting any figures, emphasised the spaciousness and the picturesque variety of the buildings (fig. 30).

In addition to these isolated sheets, some of which were originally leaves of sketchbooks, one of the complete surviving sketchbooks also includes rough drawings of Oxford subjects. The 'Rhine, Strassburg and Oxford' sketchbook, used on Turner's first

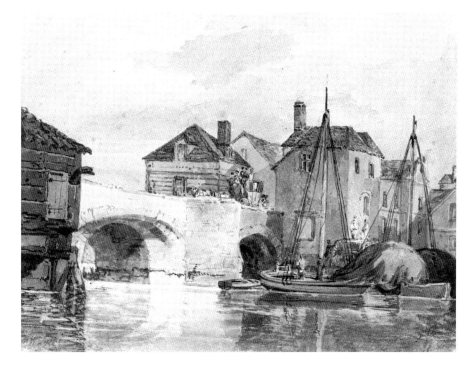

27 (RIGHT) *Folly Bridge, Oxford, c.* 1794–5. University College of Wales, Aberystwyth (cat. no. 30)

28 (BELOW) *Folly Bridge from the South East, c.* 1797. Tate Gallery (cat. no. 31)

29 (BELOW RIGHT) *Folly Bridge from the North West, c.* 1797. Tate Gallery (cat. no. 32)

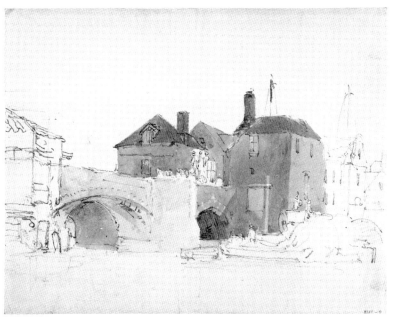

continental tour in 1802, was probably conveniently at hand when Turner made a visit to Oxford after his return to England, perhaps on the way to Sunningwell. Several sheets record a walk around Oxford, beginning on Magdalen Bridge (ff. 19, 29v.), crossing to the fields on the south side of the London Road up Headington Hill (fol. 8), and returning to Magdalen Bridge (fol. 46), before moving to the more distant views from the south-west and west on the way to Sunningwell (ff. 47, 48v.). An isolated view of

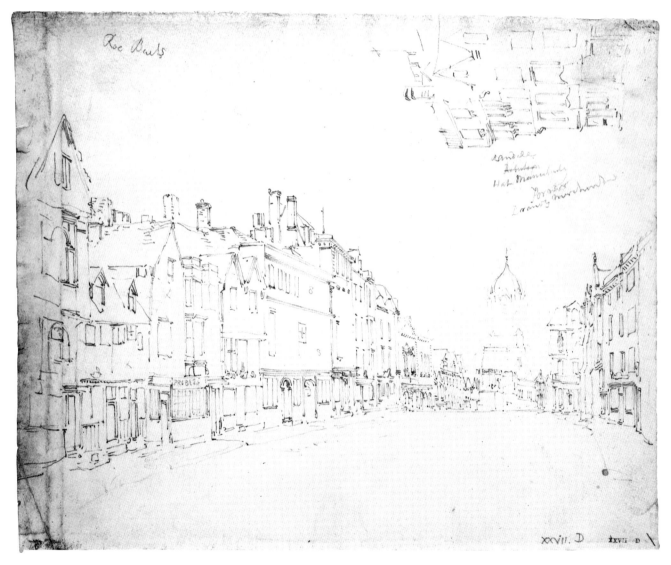

30 *Christ Church from the Cornmarket*, c. 1798. Tate Gallery
(cat. no. 39)

Broad Street and the Clarendon Building (fol. 25) shows Turner's only view of Wren's other architectural masterpiece in Oxford, the Sheldonian Theatre.

These few leaves are the last and least substantial of Turner's views of Oxford from his youth and first maturity. The commissions and experiments he had made since 1787 reveal his restless imagination, his ambition as an architectural draughtsman, and his ability to curry favour with patrons despite his personality, which assured him the most important commission available locally in Oxford, to design the head-piece for the *Oxford Almanack*.

# 2

# The Designs for the *Oxford Almanack*

By the late 1790s, Turner was in some demand for topographical watercolours made for reproduction. He had established his name at the Royal Academy exhibitions, and his work had been engraved for popular periodicals such as the *Copper-Plate Magazine* and *The Pocket Magazine*, even if on a minute scale.[1] He had also received several important commissions, among them one for a series of watercolours for a projected history of Wiltshire by Sir Richard Colt Hoare of Stourhead. The history was never published, and Turner's watercolours never engraved, but the surviving works, such as eight large watercolours of Salisbury Cathedral, confirmed that Turner was one of the leading architectural draughtsmen of the day, able to invest his buildings with sublime grandeur without neglecting curious or interesting details when necessary.[2] In 1797–8, he was commissioned by the Delegates (the trustees of the Oxford University Press) to make the first two of what eventually became a series of ten watercolours to be reproduced in the *Oxford Almanack*, the annual calendar published by the University Press and widely distributed and collected. Not only was this the most prestigious commission Turner had so far received, it was also the first time his work had been engraved on a satisfactory scale, and consequently the first time he was able to establish a close relationship with an engraver. In accepting the commission, Turner also agreed to work within the restraints of a publishing venture that was already over a century old, and participate in an essentially antiquarian tradition of disseminating the image of Oxford.

The Clarendon Press, as the University Press at Oxford was known thanks to the profits from publishing Lord Clarendon's *History of the Rebellion*, had issued unillustrated calendars since the early seventeenth century, but its first illustrated almanack was not published until 1674.[3] This was a huge allegorical composition in the spirit and manner of contemporary French almanacks,[4] but, perhaps owing to the expense of producing an engraving on such a scale, this was quickly replaced by less taxing allegorical headpieces of smaller size, generally derived from Old Master prints and drawings, which were engraved separately from the calendar below. The first of a new phase of *Almanacks* showing the buildings of Oxford was inaugurated in 1716, with a proposed design for the Radcliffe Library, and this trend was consecrated between 1723 and 1762 with views of the Oxford colleges, complete with often fanciful portraits of their founders and benefactors. Many of the subjects, which showed proposed or recently completed new buildings, must have been decided by the Delegates themselves, and the college of the Vice-Chancellor was invariably illustrated during his period of office.

The designs developed erratically during the eighteenth century. After several years of indecision, with a temporary return to the the elaborate allegories of the beginning of the century, and a charming interlude with two pastoral landscapes by John 'Baptist' Malchair in 1767–8, they entered a long period of stability in 1768, when the mechanics of commissioning and printing the *Almanacks* were put in the hands of William Jackson, the Oxford partner in one of the administrative divisions of the Clarendon Press, the Bible Press. He immediately commissioned the

fashionable London artists, Edward Rooker and his son, Michael 'Angelo', to be both designers and engravers.[5] The Rookers were distinguished draughtsmen of architectural subjects, able to create picturesque compositions enlivened by diminutive figures of dons and undergraduates and townspeople. Until his death in 1774, Edward engraved his son's designs; thereafter, Michael 'Angelo' performed both tasks. Their almanacks represent something of an ideal, accurate in topography yet engagingly pictorial in effect. They also provided a record of some of the most attractive buildings in Oxford, with a distinct predilection for recent classical architecture. Yet, so skilful were they that even views of college quadrangles, usually claustrophobic and often monotonous, appear airy and agreeable.

For some unknown reason, this happy arrangement with Jackson, and therefore with Rooker, was ended in 1788–9, and matters drifted for several years. Daniel Harris, a pedestrian local artist, was commissioned to make four designs, engraved by Isaac Taylor, and John Dixon another two, engraved by Wilson Lowry, for the *Almanacks* of 1789–94. In 1794, a much more stable contract was agreed for the artist, followed by a similar contract for the engraver in 1796. Turner's friend and associate, Edward Dayes, was commissioned to make a group of designs, for which he was paid £31. 15s. 2d. 'on account of Drawings for future Oxford Almanacks' in 1794, and £22 for 'the Remainder of his Bill of 40 Guin. for 6 Views designed for future almanacks' in the following year.[6] Dayes's first two designs were engraved by J. Dadley, but in 1796, the Press also contracted with a new engraver, ordering 'That Mr. Basire be employed for the future to engrave the Oxford Almanacks, at the price of fifty guineas, or more in proportion, if there be extraordinary work, besides all incidental expenses, he having stipulated to send a proof before the long vacation.'[7] The last point, that a finished proof should be available before the University dispersed in July, would require the artist to have sent his watercolour some months before, imply-

ing a similar deadline to that for the Royal Academy exhibitions, which opened in late April.

The existence of two engravers called James Basire raises the insoluble question as to which was given the commission for the *Almanacks* in 1796. The family firm had begun with Isaac Basire (1704–1768), who had probably taught its most distinguished member, his son, James I (1730–1802). This James was one of the great virtuosos of the burin, able to translate contemporary history paintings and watercolours of buildings and landscapes as well as the complicated textures of bones and the inscrutable characters of ancient manuscripts. He was an ideal engraver to the Society of Antiquaries. His son, James II (1769–1822), was by comparison a rather pedestrian artist, but succeeded his father at the Antiquaries, and was also much employed by the Oxford University Press for engravings for text books and other technical engraving. It has been argued that James Basire I continued to work until his death on 2 September 1802, and was therefore responsible for all the *Almanacks* until that date.[8] In the light of the complaints about the engraving of the later *Almanacks*, this is possible, in which case one must assume that the contract signed with 'Mr Basire' in 1796 was transferred to his son on his death, and no record of this made at the Press.

There is no immediately conclusive explanation for the decision of the Delegates of the Press to commission two watercolours from the twenty-four year old Turner in 1798. They still had in hand two by Dayes, which were engraved in later years and therefore could not have been rejected as unsatisfactory. As we have seen, Turner knew at least one of the Delegates, the Dean of Christ Church, and he may have had other influential friends in Oxford through his connexion with Dr Monro.[9] In 1799, he was paid £21 for 'two views for Almanacks', the first of his ten designs.

31 (RIGHT) James Basire after Turner, *South View of Christ Church, &c. from the Meadows*: the *Oxford Almanack* for 1799. Ashmolean Museum (cf. cat. no. 40)

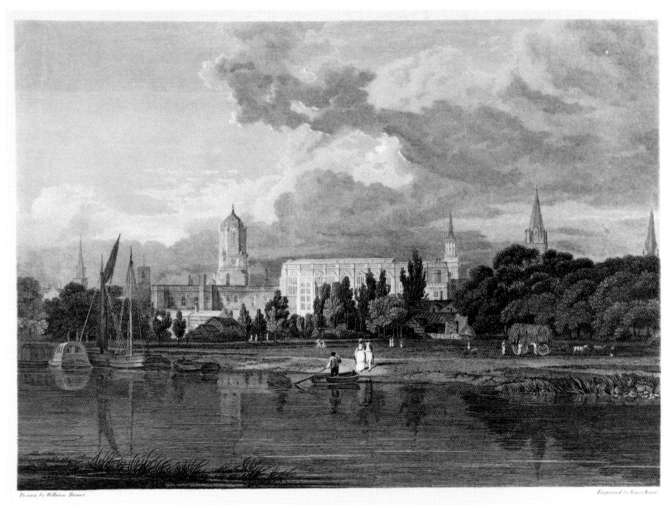

Drawn by William Turner.                    Engraved by James Basire.

*SOUTH VIEW of CHRIST CHURCH, &c. from the MEADOWS.*

Although the fee was not high, Turner would have been aware that, for an ambitious artist, the assured sale of nearly two thousand prints featuring his designs, to the most important and influential patrons and collectors in the country, was priceless publicity.[10] The subjects of his designs were probably decided by the artist himself, since, unlike the later work by Hugh O'Neill, which is specified in detail, there is no indication in the accounts of this being the case for Turner, or indeed his predecessors. The two completed in 1799 form a distinct pair, one an idyllic river scene with the great mass of Christ Church on the horizon, the other a closely examined view of a typical college quadrangle. No doubt, the young artist was hoping to prove his versatility to obtain further commissions.

*South View of Christ Church, &c. from the Meadows*: the *Almanack* for 1799 (pl. 12, fig. 31)
Given Turner's close links with Christ Church, and, as we have surmised, with its Dean, Dr Cyril Jackson, the College would have appeared a natural choice for Turner's first *Almanack*. He chose not to show any of the buildings or views he had already drawn, many of which were in any case of unsuitably vertical format, but a distant view across Christ Church Meadow, the college buildings silhouetted against the sky, and the timeless activities of the farmer in the foreground. Christ Church Meadow, which lay just to the south of the old city wall, had belonged to the college since Wolsey's foundation, and the pasture leased to tenant farmers. It was also a favourite walk for members of the university, providing Malchair's pupils with some of their most characteristic drawings, and the master himself with one of his two distinctive designs for the *Almanack*.[11]

Turner's view is taken from the south-east, from the opposite bank of the Thames, and is carefully orchestrated to include both town and country in one unified scene. It is late afternoon in high summer. In the meadows, the hay has just been cut, and a loaded haywain begins its short journey to some nearby stable.[12] Two figures, an undergraduate and a girl, stand at the water's edge hoping to cross to Grandpont in the ferry. The lowering sky adds a note of drama to this idyll, contrasting strongly with the brilliance of the buildings.

*A View of the Chapel and Hall of Oriel College, &c.*: the *Almanack* for 1801 (pl. 13, fig. 32)
Oriel College was founded in 1326 by Edward II, having been established two years earlier by his almoner, Adam de Brome. In common with most colleges, the mediaeval buildings were pulled down in the seventeenth century and replaced by the present formal quadrangle, with the traditional arrangement of hall on the left and chapel on the right, although, owing to the shape of the site, the chapel lies perpendicular to the hall. In the eighteenth century, the second quadrangle was added, in effect only half a quadrangle until the construction in 1788–9 of the library to house the bequest of Edward Lord Leigh. The library, designed by James Wyatt, was recognised by one contemporary as 'the finest classical building in Oxford'.

Oriel was not an obvious choice for Turner's other design submitted in 1799: the college had not yet attained the intellectual distinction it reached in the 1820s, when its Fellows, Newman and Pusey, set about the wholesale reform of the Church of England. Nor are its buildings distinctive, save the library, whose construction the Rookers had already made the subject of the *Almanack* for 1791. Indeed, one commentator in 1764 went so far as to claim that there was 'nothing very remarkable' about the front quadrangle.[13] The college did, however, boast among its old members Dr Thomas Monro, and this may account for Turner's choice.[14] Moreover, he had already drawn the exterior looking towards the University Church several times,[15] and was no doubt familiar with the quadrangle too.

The view is taken obliquely from the main gate, and the perspective manipulated so that the south and east

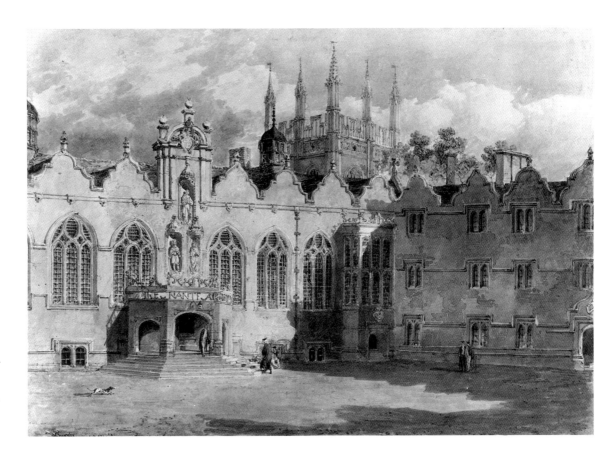

32 *A View of the Chapel and Hall of Oriel College, &c.,* c. 1798–9. Ashmolean Museum (cat. no. 41)

sides of the college have the curiously splayed appearance which became almost the hallmark of Turner's Oxford drawings. Behind looms the tower of Merton College Chapel, providing Turner with another favourite compositional device which he had used extensively at Christ Church, of a tower decapitated by a horizontal range. The porch leading into the hall bears an inscription in open masonry, *Regnante Carolo*, recording the construction of the east range in 1637–42, during the reign of Charles I. Above, in the niches, are bad statues intended for Charles I, Edward II, and the Virgin, to whom the college is dedicated.

Evidently satisfied with the first two designs, the Delegates proceeded to commission another watercolour, at the same rate of 10 guineas, which were paid in 1801. For this commission, Turner chose a quite different view, the first interior ever made for an

*Almanack*, but one of many architectural interiors he was producing at this period.

*Inside View of the East End of Merton College Chapel*: the *Almanack* for 1802 (pl. 15, fig. 33) Merton College chapel is the most spacious of the Gothic chapels in Oxford, and established the pattern on which the remainder were built. The founder of the college, Walter de Merton, planned a huge edifice, of which only the choir, transepts and crossing were completed. They date from the late thirteenth century, and the huge east window, with its seven lights and roundel of twelve spokes, is one of the most magnificent in England of this date. It provides the focal point of Turner's watercolour, emphasised by the striking black and white floor which, once again, splays out exaggeratedly to the right. For once, the diminutive figures at the altar are no distraction. The sun shining through the window gives the interior a sombre

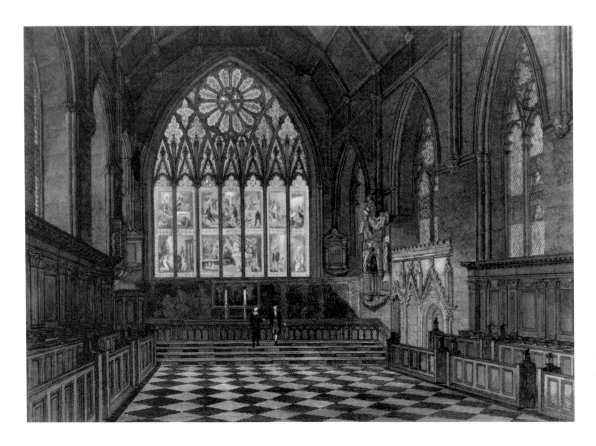

33 James Basire after Turner, *Inside View of the East End of Merton College Chapel*: the *Oxford Almanack* for 1802. Ashmolean Museum (cf. cat. no. 42)

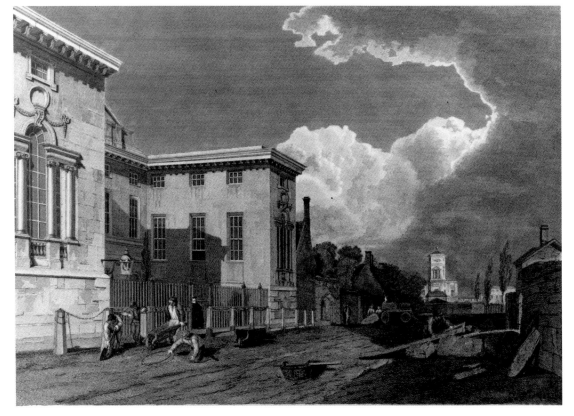

34 James Basire after Turner, *A View of Worcester College, &c.*: the *Oxford Almanack* for 1804. British Museum (cat. no. 43b)

majesty, conveyed in rich colours, while minutely drawn details, such as the lettering at the bottom of the window, add an antiquarian interest.

The Delegates had received three magnificent designs from Turner, engraved to their apparent satisfaction by Basire, but were undecided as to whether to commission any further designs from him. They still had one by Dayes, which was engraved as the *Almanack* for 1803, and commissioned Turner's friend, William Delamotte, to make a watercolour, for which they paid him only 5 guineas, half Turner's fee, in 1802.[16] It may be that they wished to find a cheaper artist than Turner; or that they feared his growing reputation would encourage him to demand higher prices; or that some of the Delegates had expressed reservations about his architectural distortions. By the following year, they had decided: Delamotte's design was discarded, and the Delegates demonstrated their confidence in Turner by ordering a further seven watercolours, to be paid at the same rate of 10 guineas each. By now, Turner was a full member of the Royal Academy, and one of the most celebrated artists in England, but there is no evidence that he was less committed to this work. The watercolours were delivered in time for the first to be engraved for the *Almanack* for 1804, which should therefore have been in the first few months of 1803, and the payment to Turner of £73 10s. was duly recorded in 1804. It may not be coincidence that the first of this group to be published was a view of Worcester College, whose Provost, Dr Whittington Langdon, had recently been elected Vice-Chancellor and was thus *ex officio* a Delegate of the Press. Indeed, he may even have stipulated the subject.

### *A View of Worcester College, &c.*: the *Almanack* for 1804 (pl. 14, fig. 34)

Worcester College was the only college in Oxford to be founded in the eighteenth century (in 1714), and its site outside the old city walls led it to be known affectionately in the early nineteenth century as 'Botany Bay'. Its position surrounded by meadows enabled the architects, Nicholas Hawksmoor and Dr George Clarke of All Souls College, to design a wholly original plan for a college, on the scale and with many of the features of a country house, albeit one incorporating the mediaeval buildings of Gloucester Hall. The remarkable entrance to the college was erected in the 1770s, with the hall (in the left block) and chapel (in the right) decorated by the indefatigable James Wyatt and not completed until 1791. Turner's watercolour shows the view looking northwards past the surviving mediaeval buildings of Gloucester Hall, towards the Radcliffe Observatory, completed in 1794 to designs by Henry Keene and Wyatt. It thus included two of the outstanding modern buildings in Oxford, and was, surprisingly, the first time that Worcester had been the subject of an *Almanack*. The composition is carefully arranged so that the prominent Venetian windows on the wings of Worcester College dominate the foreground, and the road (now Walton Street) leads obliquely to the Observatory. Outside the college, figures repair the road that was later to become Beaumont Street, but are more probably imaginary than real. The scene was, incidentally, the beginning of the only thorough piece of town planning in Oxford, which survived until the late nineteenth century.

### *A View from the Inside of Brazen Nose College Quadrangle*: the *Almanack* for 1805 (pl. 16, fig. 35)

Turner's view of the quadrangle of Brasenose College develops his earlier view of Oriel: the focal point of the porch at Oriel has been replaced by that of the gate tower of Brasenose, and looming over the college buildings are now two magnificently alien structures, the spire of the University Church and the dome of the Radcliffe Camera. A further point of interest is the group in the quadrangle, a lead cast of Giambologna's celebrated marble sculpture of *Samson slaying a Philistine*, presented to Charles I as Prince of Wales in 1623 and now in the Victoria and Albert Museum.[17] The cast was bought by the college from Dr George

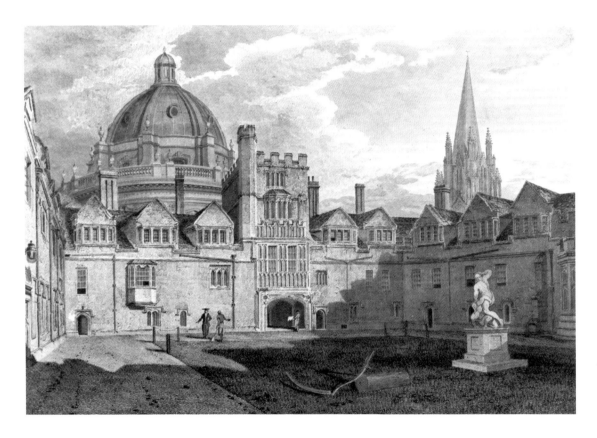

35 James Basire after Turner, *A View from the Inside of Brazen Nose College Quadrangle*, c. 1803–4. Ashmolean Museum (cat. no. 44)

Clarke in 1728, and regrettably sold for scrap in 1881. Next to it is a roller and scythe, included to break up the empty expanse of foreground. Turner's old master, Thomas Malton, included the same view among his aquatints of *Oxford*. Since it was not published until 31 December 1803, the two artists may have known each other's work.

*View of Exeter College, All Saints Church, &c. from the Turl*: the *Almanack* for 1806 (pl. 17, fig. 36) Exeter College, erected during the great building boom in Oxford in the seventeenth century, stands on one side of Turl Street, with Jesus College opposite and Lincoln beyond. Turner's vista culminates in the distinctive spire of All Saints' Church on the High Street. The whole scene is lit by the afternoon sun of winter. As in the watercolour of Worcester, Turner has added road-menders as staffage, and manipulated the perspective to include all the picturesque elements. He has suggestively included two posters on the corner of

the Turl and Ship Lane: one advertises a lecture at the Radcliffe Observatory by the Radcliffe Observer, Dr Thomas Hornsby, whom Turner may have known;[18] the other, a performance at the theatre. The original sketch for the watercolour must have included the hatchment over the gate of Jesus College, indicating that it was drawn shortly after the death of the Principal, Dr Joseph Hoare, on 26 May 1802; his successor, David Hughes, was elected on 10 June 1802, by which time it would seem reasonable that the hatchment had been removed. This incidental detail is included in the watercolour but not the engraving published in 1806.

In 1806, there were ominous signs that all was not well, and that the Delegates had decided that Turner's four remaining watercolours were in various ways unsatisfactory. They ordered that 'Mr. Neill be commissioned to sketch more correctly some parts of the inside of Christ Church Hall, for the use of the Engraver of the

for the coming year,' and, moreover, 'that Mr. Neill be also commissioned to make a drawing in Indian Ink of the Chancel of St Peter's Church for an Almanack'. So dissatisfied do they seem to have become, that they even contemplated forgoing the four remaining designs in favour of one from another artist, and the accounts for the academic year 1806–7 record payments to O'Neill for 'sketches of Ch. Ch. Hall & Oxford from Headington Hill, & St Peter's Church', amounting to a total of £16 5s. 6d. That the perceived defects were not all Turner's can be seen from another entry in the same year, noting that Basire had been summoned before the Delegates, and 'engaged to pay greater attention to the engraving of the Oxford Almanack, and to execute it in a better manner, than has been done for some years past', and that 'two Drawings, the one a View from Headington Hill, and the other of the Fellows' Building &c of Corpus College, be now put into his hands expressly for the purpose of further Trial.'[19] Although Basire must have agreed to undergo this trial,

he apparently avoided doing so for some time, for the next watercolour to be published was of neither of the trial pieces.

*Inside View of the Hall of Christ Church*: the *Almanack* for 1807 (pl. 18, fig. 38)

The hall at Christ Church is the most splendid of any Oxford or Cambridge college, and the only part of Wolsey's college that still reflects the magnitude of his ambitious building scheme. It was completed shortly before his downfall in 1529, and measures 115 feet by 40, and is 50 feet high. As Turner would have known, Charles I assembled his parliament here in 1644, and it was the focal point of many later royal visits. The hammer beam roof was modified after a fire in 1720, but the windows are original, including the bold bay window lighting the high table on its dais. The portraits hanging against the wainscotting show eminent old members of Christ Church, surrounding the second founder of the college, Henry VIII, and

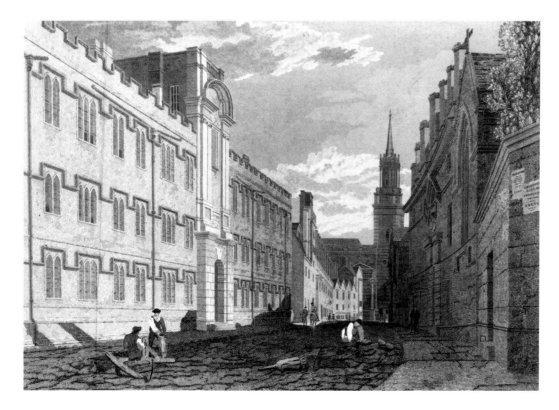

36 James Basire after Turner, *View of Exeter College, All Saints Church &c. from the Turl,* c. 1803–4. Ashmolean Museum (cat. no. 45)

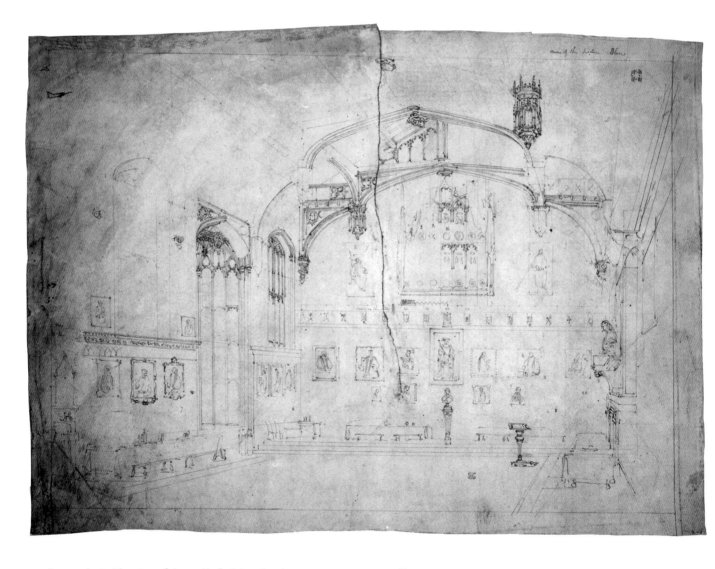

37 (ABOVE) *Inside View of the Hall of Christ Church*, c. 1799–1800. Tate Gallery (cat. no. 46)

38 (RIGHT) *Inside View of the Hall of Christ Church*, c. 1803–4. Ashmolean Museum (cat. no. 47)

were a considerable tourist attraction, being the only set individually enumerated in successive editions of the *Companion Guide*.[20]

Turner had already drawn the entrance to the hall as it was being modified by James Wyatt in 1799–1800, and the detailed sketch he made of the interior may have been made at the same time (fig. 37). It is the only preliminary study for any of the *Almanack* watercolours to survive, and includes measurements and indications of perspective as well as colour notes, much

like his other large drawings of architectural interiors at this time. More unusually, it is also painstaking in depicting details of individual bosses with coats of arms round the walls, shorthand indications of the different styles of picture frames, and incidental accidents, among them a painting hanging crooked, and the tables laid for dinner. In the finished watercolour, Turner added two figures putting out utensils, but otherwise followed his drawing very closely. Each portrait is distinguished from its neighbour, each coat

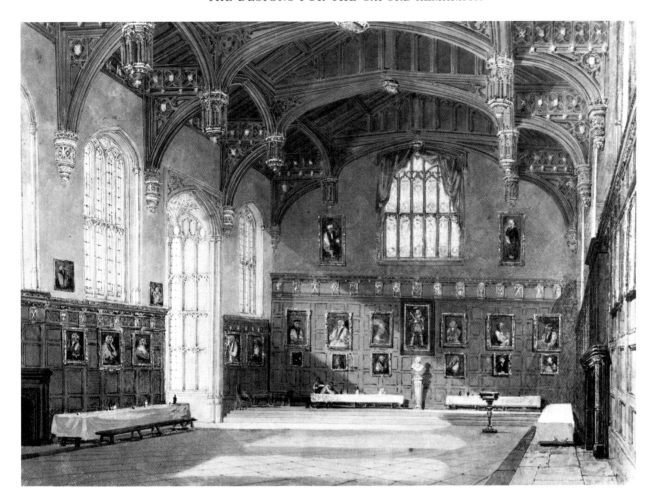

of arms from that adjacent, and the tracery and stained glass in the windows is lovingly delineated. It is one of the artist's most successful works of this kind, creating a general effect of monumental grandeur from minutely detailed components.

Yet the Delegates were not satisfied, and commissioned Hugh O'Neill to sketch some parts more correctly. Hugh O'Neill (1784–1824), who was eventually to replace Turner as the draughtsman for the *Almanack*, was a pedestrian local artist, whose enthusiasm for accuracy matched Turner's for poetry. The nature of his revisions of the view of Christ Church hall is not known, but comparison between the drawing and

the engraving reveals only slight differences, mostly in the larger size and greater distinctiveness of the portraits. One unusual aspect of Turner's drawing is the amount of scratching out of the pigment to reveal the white paper as highlights below, especially in the gilt picture frames and the roof. This was probably done for Basire's benefit.

*A View of Oxford from the South Side of Heddington Hill*: the *Almanack* for 1808 (pl. 19, fig. 39)

Any visitor arriving by coach from London had his first sight of the city skyline as he travelled down Headington Hill. The view was surprisingly little

painted, however, and Turner's most memorable predecessor was Malchair, in an atmospheric water-colour of 1791.[21] Turner himself had already represented the same view in his work reproduced in the *Copper Plate Magazine* in 1795.[22] Moreover, he had drawn a similar view more recently, slightly further round Headington Hill to the north.[23] For his water-colour, Turner shows the coach on the London road winding down the hill through the cutting, the spires and towers of Oxford swathed in mist in the background. In the foreground, a plough serves as a reminder of the proximity and prosperity of the local agriculture.

*Part of Balliol College Quadrangle*: the *Almanack* for 1810 (fig. 40)

The *Almanack* for 1810, Balliol College Quadrangle, seems to have given endless trouble. The subject itself was unpromising: the fifteenth-century quadrangle was almost completely devoid of picturesque features, and Turner must have been pressed to find a sympathetic view. Indeed, it is almost certain that the only reason he chose Balliol was at the behest of the Master, Dr John Parsons, a Delegate of the Press. The choice Turner faced can be judged from the engraving by Loggan of 1675 – the appearance of the college had changed little since the 1670s. The quadrangle was built over several

39 James Basire after Turner, *A View of Oxford from the South Side of Heddington Hill*: the *Oxford Almanack* for 1809. Ashmolean Museum (cf. cat. no. 48)

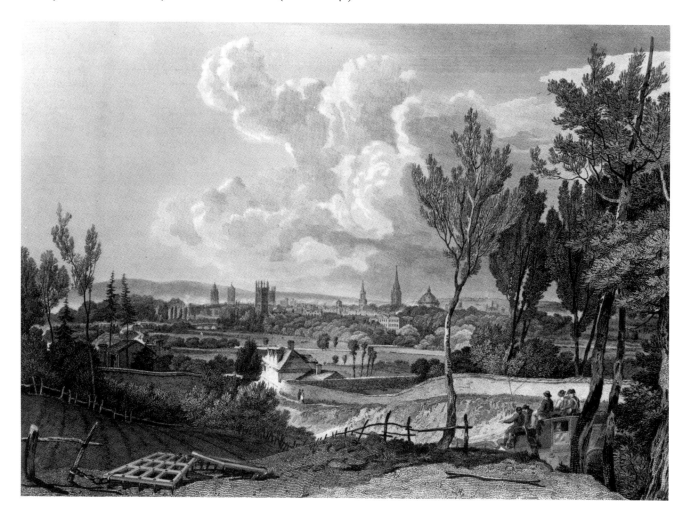

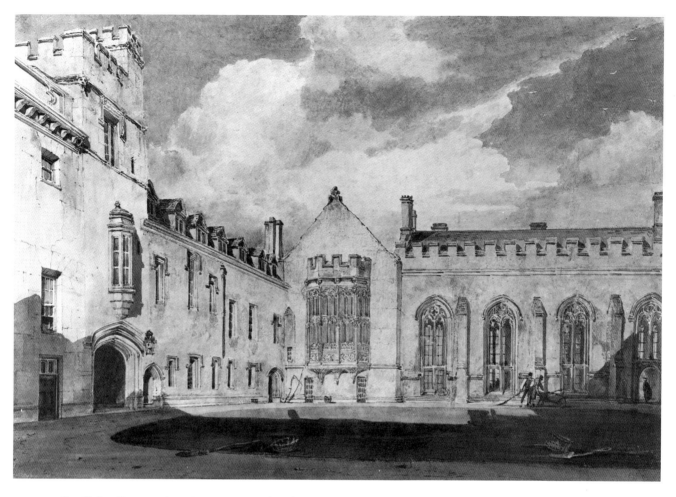

40 *Part of Balliol College Quadrangle, c.* 1803–4. Ashmolean Museum (cat. no. 49)

centuries on the standard Oxford pattern, and mostly Gothic: the west range consisted of the hall and buttery, the north of library and chapel, and the south of the central gatehouse and tower. The chapel (1522–9) was more notable for its stained glass than its architecture, and the east range also lacked distinction. Turner was therefore reduced to focusing on the oriel window of the buttery, seen in an oblique composition looking southwest with the gatetower. One other possible point of interest was that James Wyatt had added battlements to the whole quadrangle in 1791–4. Comparison with the published *Almanack* shows that he made the oriel window too long, the rectangular windows beneath it squashed, and the whole range too

tall. The details are picked out in a delicate and fine brush in a different brown watercolour, but the sky is filled with one solid cloud. The tradition that Dr Parsons objected to the shadow, claiming it could not be cast across the quadrangle in the way Turner had drawn it, may be apocryphal, for O'Neill's shadow is similar. His architecture is not only more accurately drawn, but more convincing – Turner did not choose the subject, and could make nothing of it.

Almost as soon as the watercolour was delivered, an entry in the Orders and Accounts for the Press, dated 11 December 1805, records 'That the Master of Balliol be commissioned to employ M^r Storer to engrave the Drawing of Balliol College for the Almanack'.[24] Dr

Parsons was the architect of Balliol's reputation in the nineteenth century, and a formidable opponent.[25] His insistence on chosing another engraver for the *Almanack* of his own college should therefore have come as no surprise. His choice was also predictable: James Storer made his name as an engraver of topographical views for Britton and Brayley's *Beauties of England and Wales*. He later provided the pedantically accurate illustrations to W. M. Wade's *Walks in Oxford* and with his brother, to two illustrated guidebooks to Oxford published in 1821–2.[26] Parsons's commission was not acted on immediately, and two years later, Hugh O'Neill was paid two and a half guineas for 'correcting a drawing of Balliol College', which was clearly Turner's . When the *Almanack* the was eventually published, the engraving was credited to Storer and the drawing to O'Neill, and the differences between O'Neill's drawing and Turner's confirm that what was engraved was a wholly new drawing, and that the indignation of most commentators at O'Neill's being credited at all is wholly misguided.

*View of the Cathedral of Christ Church, and Part of Corpus Christi College*: the *Almanack* for 1811 (figs. 41, 42)

The Delegates reserved as the last of Turner's designs submitted in 1804 the view of Christ Church Cathedral from Corpus Christi College Gardens, perhaps because it had already been the subject of an earlier *Almanack*, by Rooker in 1782, and of published plates after Dayes and Delamotte too.[27] Turner's design is a more successful variant of one he had made in *c*. 1795 (and which had been published in 1807), containing the same elements of garden, complete with gardener, in front of the top-heavy form of the spire of Christ Church Cathedral. Instead of the Gothic range of the Deanery to the right, the new watercolour shows the grandly neo-classical front of the Fellows' Building of Corpus Christi College, leading the perspective towards the cathedral and Tom Tower.

This *Almanack* proved to be the most problematic for Basire. In the first state, he followed Turner's watercolour implicitly, so that the respective positions of the north transept and Tom Tower are too close together. In the second, they are too far apart. In the third, Turner took issue with the shape of Tom Tower itself, for Basire had made all the lancets the same. Turner tetchily remarked on the touched proof, 'Tom is not like. Get Daye's or Rooker's or Delamotte's to look at. It has Crocketts at the angles up to the sets of the leadwork.'[28] The final state of the print accurately reproduces Turner's revised wishes.

The watercolour itself is faded and in poor condition, probably from careless treatment in Basire's studio. Indeed, when Joseph Skelton came to engrave the whole series of drawings for his *Oxonia antiqua restaurata* in 1821, he received a separate payment from the Press for the repair of several of Turner's watercolours, which would account for the consolidated holes and retouching in this and other watercolours.[29] Skelton's work was another reminder that, despite his eminence, Turner was in Oxford just one of a large team employed to record the city. There was yet another reminder in 1865, when a prospectus was published advertising for subscribers to restrikes of the surviving *Almanack* plates, which were published in the following year. It would be wrong, however, to see Turner's relationship with the Clarendon Press as the struggle between antiquarian and poetic reality, for, in accepting the commission, Turner would have known what was expected of him and agreed to conform to the conventions. he succeeded so well in nine designs is to the credit of artist, engraver, and patron, and the lessons Turner learnt in the process would be put to good use in his next Oxford commission.

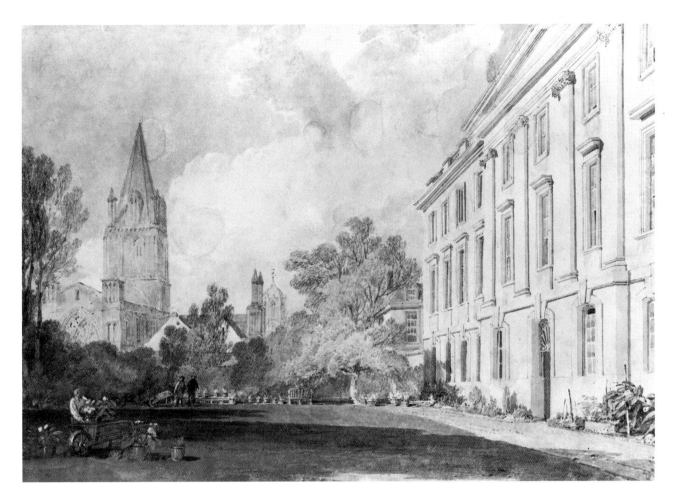

41 (ABOVE) *View of the Cath-edral of Christ Church, and Part of Corpus Christi College,* *c.* 1803–4. Ashmolean Museum (cat. no. 50)

42 (RIGHT) James Basire after Turner, *View of the Cathedral of Christ Church, and Part of Corpus Christi College:* the *Oxford Almanack* for 1811. Ashmolean Museum (cf. cat. no. 50)

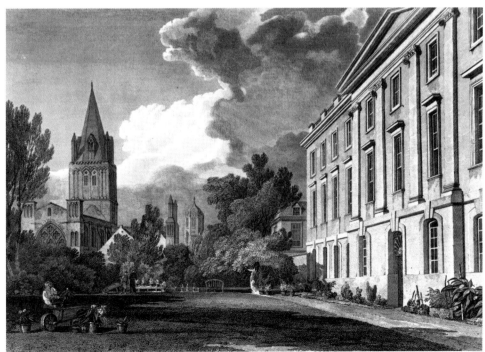

# 3

# Two Oil Paintings for James Wyatt

Even before the last of his *Almanacks* was engraved, Turner had occasion to return to Oxford, perhaps to visit his uncle at Sunningwell, perhaps on one of his numerous tours northwards or westwards. In 1809–10, he painted one of the most remarkable townscapes in the history of English art, and established an Oxford businessman on a new path to the summit of success as a print publisher and picture dealer.

James Wyatt (1774–1853) is remembered today largely as the friend of the young Pre-Raphaelites at Oxford, and the subject of one of J. E. Millais's most enchanting and original portraits, *James Wyatt and his Grand-Daughter* (fig. 43).[1] Millais later described him as 'certainly the most upright fine old gentleman I ever remember to have met in my life'.[2] Apart from the bare fact that he commissioned two oil paintings from Turner, however, his early career has remained obscure.

Like Turner, Wyatt was a self-made man, who, within the confines of Oxford, achieved comparable eminence.[3] He was born in modest circumstances on 14 March 1774, the son of the baker, Thomas Wyatt, and apprenticed to the carver and gilder, Robert Archer, in 1790.[4] In 1805, he established himself as a carver and gilder at 115 High Street, a handsome double-fronted Georgian shop now occupied by Hobbs, the shoe-shop. He married Mary Cooke at St Peter's in the East on 13 February 1806, and had six children. His professional life was centred on the business of frame making, although most of the frames which do survive with his label are no more distinguished or imaginative than the work of any other leading provincial frame maker of the time. One frame

does stand out: the extraordinary confection surrounding the rather dull portrait of Wyatt by his son-in-law, John Bridges, dated 1841 and now hanging in Oxford Town Hall. This was presumably designed by Wyatt himself, and incorporates masonic emblems reflecting his long interest in the subject: he was initiated in the Alfred Lodge, Oxford in 1816, and became its Master in 1848.

Following the example of many frame makers, Wyatt gradually began to deal in pictures and prints, and eventually to publish prints himself. This last activity is extremely difficult to document, thanks to the complete lack of any official records relating to the publication of prints in England. From the engravers' plates in Wyatt's posthumous sale at Christie's, however, it is possible to reconstruct his publishing activities, if only partially. While it is possible that his son, James Wyatt the younger, who succeeded him in business, retained some plates for further use, the inclusion of the most prestigious would indicate the liquidation of the entire stock. The earliest plate, dated 1811, set the tone for what followed: a mezzotint by Charles Turner of John Cooke, President of Corpus Christi College, after the fashionable portrait painter, John Hoppner. There followed other portraits, generally in mezzotint, invariably of local figures, of whom a few attained national prominence. Their appearance was irregular: Sir Thomas Pope, the founder of St John's College, Oxford, by William Skelton after 'Holbein', 1821; Edward Copleston, Provost of Oriel, by S. W. Reynolds and Samuel Cousins after Thomas Phillips, 1822; the violinist Franz Cramer, by B. P. Gibbon after W. Watts, 1826; Dr Michael Marlow, President of St

John's, by S.W. Reynolds after Thomas Phillips, 1828; Dr Edward Burton, by Cousins after Corbet, 1837; Donald McLean, M.P. for Oxford, by Cousins after John Bridges, 1837; and lastly, 'a bust of the Revd H. Newman, by Humphrys', 1841, in other words, John Henry Newman, leader of the Tractarian movement, while vicar of the University Church of St Mary the Virgin.[5] Such a list shows only that Wyatt had a preference for mezzotints, patronised the leading practitioners, Cousins and S.W. Reynolds, and clearly did not depend on publishing as a mainstay of his business.

In the same sale, there are large lots of miscellaneous prints of all kinds, indicative merely of a varied and prosperous trade and an eclectic taste as both dealer and collector. It is said that, when Turner visited him, he was especially struck by Raphael Morghen's engraving after Guido Reni's *Aurora*.[6]

From his various activities, Wyatt became one of the most successful businessmen in Oxford, and increasingly prominent in local politics. He was elected to the Corporation of Oxford in 1815, advancing to Sherriff of Oxford in 1839, Alderman in 1841, and serving as Lord Mayor in 1843–4. Moreover, according to his obituary, he 'was devotedly attached to his native city, and he delighted in the study of its history and antiquities, upon which subjects there was no one more accessible or more competent to give information'.[7] One of his more curious purchases as a dealer was the wooden coat of arms from the original town hall, and his garden was filled with sculptures from other demolished historic buildings.

Many of Wyatt's later interests are illustrated by his patronage of Turner in 1809–12, which was apparently

43  John Everett Millais, *James Wyatt and his Grand-Daughter*, 1848. Lloyd-Webber Collection.

44 (LEFT) *The High Street looking West*, c. 1800. Tate Gallery (cat. no. 37)

45 (RIGHT) *The High Street looking West*, c. 1800. Tate Gallery (cat. no. 36)

46 (BELOW RIGHT) *Studies of Parts of the High Street Fronts of All Souls College and University College*, c. 1798. Tate Gallery (cat. no. 38)

his first venture into print publishing. It was also Turner's best documented commission, for, as a canny businessman, Wyatt preserved the letters from the artist relating to both paintings, and they were included in his posthumous sale.[8] Happily, they are sufficiently detailed to enable us to reconstruct the other side of the correspondence.

Wyatt would have been aware of Turner's work and reputation for some years, and they may have met as early as the 1790s.[9] However, it was no doubt the success of Turner's designs for the *Oxford Almanack* which encouraged him to embark on the project of commissioning from the most celebrated landscape painter in England a view of Oxford (pl. 20) to be engraved and sold at his shop at 115 High Street. More immediately, he may have seen Turner's only other essay in oils in this vein, *London*, exhibited at the artist's own gallery in 1809.[10] The project was first discussed while Turner was in Oxford in the autumn of 1809, and by the date of the first surviving letter, 17 November 1809, negotiations were already under way. Throughout, Turner showed himself at his most amenable, clearly falling for Wyatt's charm yet unwilling to take advantage of his naïvety and inexperience.

Wyatt was at first undecided as to whether he should

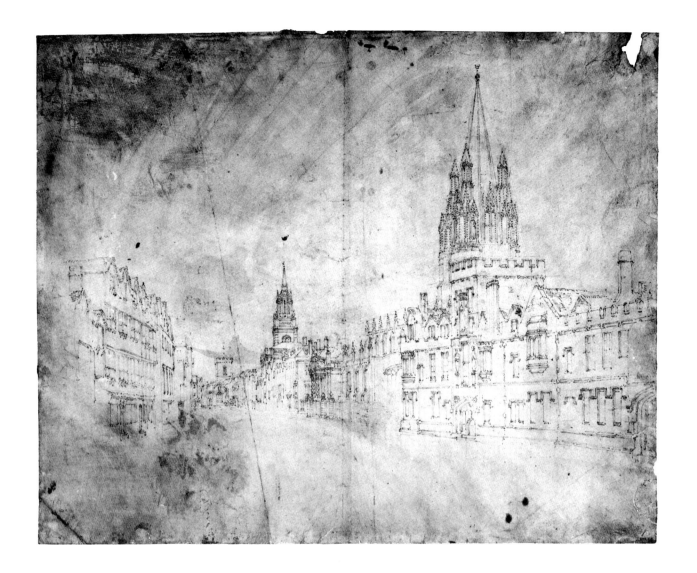

commission a watercolour or an oil painting, but the subject had already been agreed: a view of the High Street, which Turner described as 'an excellent one', and for which he already had a large sketch showing 'the entrance & part of University Coll … with do. of All Souls, St. Mary Church, All Saints, and looking up the High Street to Carfax Church' (figs. 44–5). Wyatt had initially proposed an engraving of 24 inches (wide), which, given the fullness of the subject, was perhaps too small. A couple of days later, Turner gave further guidance over the price and advised Wyatt to publish a prospectus for the print, mentioning the artist's name, before the forthcoming election for

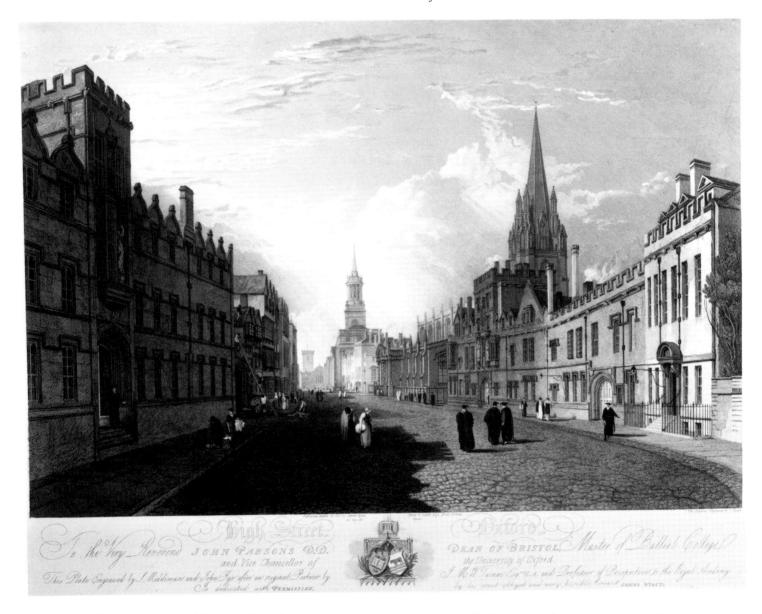

47  John Pye, Samuel Middiman, and Charles Heath after Turner, *High Street, Oxford*, 1812. British Museum (cat. no. 51b)

Chancellor after the death of the Duke of Portland, when Oxford would be full of old members, as all Masters of Arts were entitled to vote. Wyatt had evidently decided that he wanted an enormous painting to fit into a frame he already had in stock, for Turner replied that his standard size was three feet by four feet, for which he charged 200 guineas; he might have a painting half the size for half the price, while a water-colour would cost 80 guineas.

Having settled on an oil painting half Turner's normal size, Wyatt then asked Turner about the choice of engraver. While declining to take any responsibility, Turner proposed several names he thought might be suitable, among whom Basire was noticeably absent.

Although Turner had been working with engravers since the late 1790s, and had begun his own *Liber Studiorum* in 1807, he was still relatively inexperienced in this field, and only just beginning to build up the team which eventually carried out his instructions implicitly. In fact, Wyatt's proposed plate was the first large engraving after Turner apart from *Pope's Villa*, whose first state is dated 1810 and which may not even have been begun in November 1809.

The final question, and the most immediate, was that of the precise view. The drawing Turner already had in hand showed the High from All Souls to Carfax, which was supplemented by a further drawing probably made some years later, extending the front of All Souls to include the Warden's lodgings, and, on the other side of the street, the edge of University College and the gateway (fig. 46). On the same sheet are detailed studies of the gargoyles along the front of All Souls, a rare example of Turner in light-hearted mood. In the letter of 9 December, either Turner or, more probably, Wyatt, had wondered about including the baroque front of the Queen's College, which dominates the curve of the High Street before the University Church. Wyatt may even have sent Turner sketches of the houses below Queen's, but Turner eventually made up his mind to come to Oxford shortly after Christmas, 1809, to settle the matter for himself by making a supplementary large sketch, which he asked Wyatt to prepare. This must have been the study reputed to have been made from a coach in the middle of the High, now lost.[11] It would also have shown the gap in the street left by the demolition of Deep Hall, where Dr Robert Boyle lived briefly in the seventeenth century.

Once he had made this, Turner worked very quickly, and was able to reassure Wyatt in his next letter, on 4 February 1810, that 'the painting is very forward', and asked him to check details of fenestration and particular points in the architecture of All Souls'. The final stage in the painting involved the introduction of figures into this otherwise deserted townscape; for,

after all, the High was a favourite place for strolling. Once more, Turner was eager to please:

*The figures introduced are as follows: two Clericals, one in black with a master of arts gown, the other with lawn sleeves for the Bishop (being in want of a little white and purple scarf) preceded by and follow'd by a Beadle.*

He then requested precise details of dress for each of his figures, 'for I could wish to be right.' In response, Wyatt must have sent him some of the engravings of Oxford dress, such as those appended to most guide books. He must also have suggested the addition of a female figure or two, for Turner wrote back that 'I took the hint, for the sake of color, to introduce some Ladies.' In the same letter, of 14 March 1810, Turner announced that the picture was finished, and that he hoped that 'the Picture will please and that you will find your endeavours seconded and prove ultimately very advantageous.'

Attempts to persuade the engraver, Middiman, to come to see the painting before it was sent to Oxford failed, and on 14 March, Turner was asking where he should send it once he had laid on the final coat of varnish. Wyatt proudly took delivery of it soon afterwards, and announced in the local newspaper, *Jackson's Oxford Journal*, on 31 March 1810 that,

*James Wyatt, Carver, Gilder, and Picture-Frame Maker, High-Street, Oxford, respectfully informs the Noblemen and Gentlemen of the University, and the Public, that the Picture of the HIGH-STREET, from the Pencil of that Eminent Artist, Joseph Mallord William Turner, Esq. R.A. Professor of Perspective to the Royal Academy, is arrived; and that he purposes to exhibit it in his shop, for the inspection of the Subscribers and those Gentlemen who will do him the honour to call at his house, till the 10th of April, after which time it will be necessary to put it into the hands of the Engravers, Messrs. Middiman and Pye, who have engaged to execute it, in the Line Manner, and in their best style. Price to Subscribers £1 11s. 6d. Proof Impressions (of which only fifty will be taken off) £3 3s.*

He also took care to mention that he had a volume of engravings after Rubens and Van Dyck for sale. As ill luck would have it, in the same column of the newspaper, Isaac Taylor, a local drawing master living very near Wyatt, and evidently seeking to steal a march on his rival, took the opportunity to advertise to subscribers that the plate of 'his general VIEW of the High-Street, Oxford' was very far advanced, and would be ready shortly. A few weeks later, on 30 June 1810, Taylor was able to announce that he was taking advantage of the installation of Lord Grenville as Chancellor to publish his print, which, incidentally, was dedicated to the new Chancellor and half the price of Wyatt's. For his part, Wyatt repeated his advertisement, merely adding that Dr John Parsons of Balliol, Turner's old critic and by now Vice Chancellor, had accepted the dedication of his print. Meanwhile, the painting had been exhibited at Turner's own gallery in his house in Queen Ann Street in May 1810, and shortly after-wards must have been sent to the engraver, Samuel Middiman. It probably remained in his studio for the next two years, while he and his son-in-law, John Pye, engraved it. As with the painting, the figures, by Charles Heath, were no doubt added last. Although the publication date on the engraving is 14 March 1812, it was not ready for collection by subscribers until 16 May 1812, while the painting was being exhibited at the Royal Academy. The result was only the second large plate after Turner, and one of the most admired engravings of his work (fig. 47).

Turner's *High Street, Oxford* (pl. 20) is the only English townscape of the nineteenth century which can bear comparison with Canaletto's views of London of the 1750s. The subject had long been recognised as 'one of the most beautiful streets in Europe'[13], curving gently from Magdalen Bridge to Carfax, with a picturesque variety of buildings on either side. William Combe described it in 1794:

*The eastern entrance into the city is by the high-street, which is without a rival in this or any other country. It is two thousand and thirty-eight feet in length, and eighty-five broad; is admirably paved, and contains Queen's, All Souls, University, and Magdalen Colleges; with the fine churchs of Saint Mary and All Saints ... all together forming a most superb range of finely contrasted structures; while its curvated direction, by affording a gradual display, heightens the impression of its magnificent objects.*[14]

Turner's painting is based on a synthesis of the drawings he had made earlier, and on direct observation while preparing it. Given the elaborate and precise details he requested of Wyatt, it is surprising to find that a technical examination shows only that Turner added an extra gable in the roof of the lodgings of All Souls; his worries about the spire of the University Church, and the fenestration of All Souls did not result in detectable changes. The technique is unusually meticulous, almost as though Turner were working in oils what he had previously done in watercolours for the *Almanacks*. Yet the whole effect is majestic and graceful, the street wider than in reality, slightly straighter, and, despite being painted in the middle of winter, bathed in the soft sunlight of early spring. Several groups of figures are carefully arranged, mostly academics to the right, and townspeople to the left, with the workmen pulling down Deep Hall in the shadows, and boys outside the gate of University College gathering up a spilt basket of oranges. The restricted harmony of blue sky and golden architecture is punctuated by black and white costumes, and disturbed only by the women added 'for the sake of colour'. Turner was never to paint such a picture again, and the special circumstances of its commission must have contributed largely to its success.

Wyatt was so pleased with the painting of *High Street, Oxford* that he paid the agreed fee of £105 even before taking delivery, and was soon wondering whether it would be worthwhile publishing a second print. The first time the subject was mentioned, Wyatt apparently

suggested 'the other end of the High St',[15] which might have incorporated a view of Wyatt's shop, and would certainly have been dominated by the spire of All Saints Church. This came to nothing, and records of negotiations do not survive. Pye seems to have agreed to engrave the pendant as soon as he had completed the engraving of *High Street, Oxford*, which Turner calculated should take some three years.

Turner began the pendant, *A View of Oxford from the Abingdon Road* (pl. 21), at Christmas 1811. He first settled on the subject with Wyatt, who accompanied him to the vantage point just off the Abingdon Road to the south of Oxford. The spot was already very familiar to Turner, and he was able to mark it exactly on the map he sent Cooke nearly ten years later.[16] Turner made only one preparatory drawing, large and detailed (fig. 48), economical in the foreground but full enough to satisfy even Wyatt, in effect the kind of 'contract

48 *A View of Oxford from the Abingdon Road*, 1811. Tate Gallery (cat. no. 52)

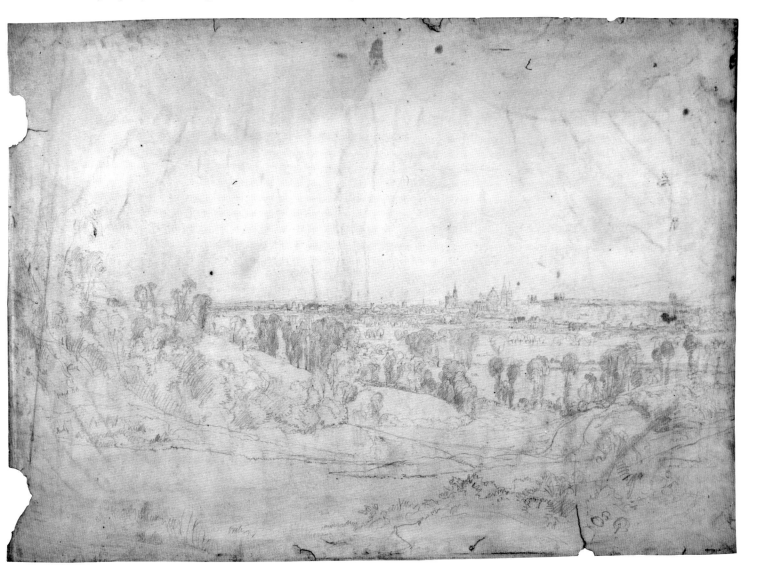

'drawing' provided by the Old Masters for their patrons. It includes brief reminders of such features as the road to the right, rushes, gravel, and water in the foreground, and meadow in the middle distance. In the view itself, Oxford is seen massed on the skyline, dominated by Christ Church, and gradually becoming obscured by trees towards the right, so that only the tops of the towers of All Souls and Merton are visible, and Magdalen tower appears rather isolated far to the right. The wide expanse of fields is interrupted by farm buildings to the left of centre, and dominated by pollarded oaks and willows. In the painting, Turner followed the drawing exactly down almost to the last tree, save that he added a shepherd, sheep dog and

49  John Pye and Charles Heath after Turner, *A View of Oxford from the Abingdon Road*, 1818. British Museum (cat. no. 53b)

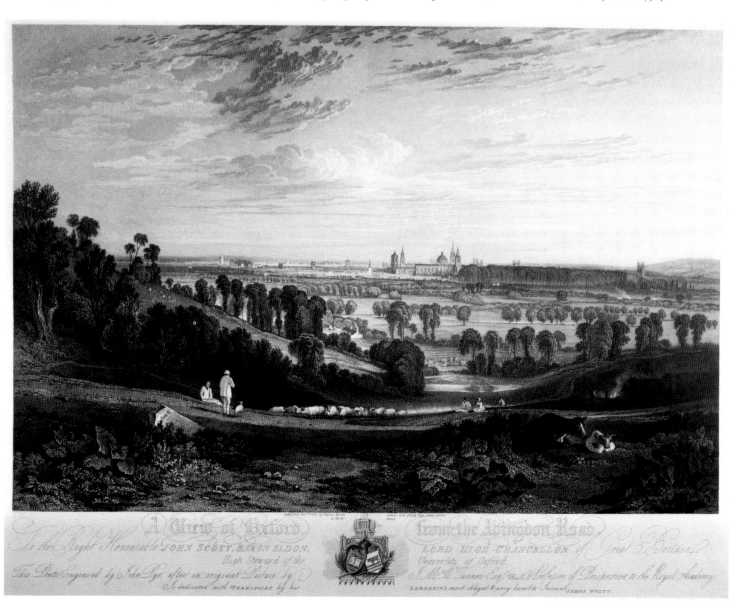

flock, and other figures and cows elegantly disposed in the meadow. The empty foreground is relieved by large-leafed plants and a prominent and improbably sited milestone inscribed *Oxford*. Once again, the clear light of early summer brings every part of the painting into focus, creating a scene of pastoral tranquillity within view of the city of Oxford. It was completed in time for the opening of the Royal Academy exhibition in April 1812, and hung with the pendant too high to be visible to the critics, none of whom noticed them. The engraving of *Oxford from the Abingdon Road* was not published until 1818, far exceeding Turner's initial estimate that Pye would take three years to complete the plate. The particular reasons are not known, but the delay was repeated and even exceeded when he came to engrave Turner's *Ehrenbreitstein* in the 1840s, for engraving Turner's work 'meant starvation … owing

to the enormous labour required and time occupied'.[17] The print was ready by 30 May 1818, when Wyatt announced in *Jackson's Oxford Journal* that proofs could be had for three guineas, and ordinary prints for £1 11s. 6d. The date published on the print itself was 13 February 1818 (fig. 49).

Given the important part he had taken in the creation of these paintings, it is surprising that Wyatt did not hang them in his house in the High, but sold them at an unknown date to Jesse Watts Russell. He did, however, commission a full-sized copy of the *High Street* as a consolation; this was included in his posthumous sale at Christie's in 1853.[18] The engravings may have launched his career as a publisher, but the paintings confirmed the humble baker's son as an important patron of modern art, fully equal to the aristocratic patrons Turner usually supplied.

# 4

# The Watercolours for *Picturesque Views in England and Wales*

Between the completion of his paintings for Wyatt in 1812 and 1830, when he was working on the most important series of watercolours of his career, Turner's visits to Oxford were for family rather than artistic reasons, and most are not recorded. His uncle at Sunningwell, Joseph Marshall, died in 1820, and it was perhaps in connexion with the legacy due to Mrs Marshall that he visited Oxford in 1821. Several very slight sketches of Oxford and Sunningwell are scattered through the 'Folkestone' sketchbook, used in that year.[1] Their disposition would seem to indicate that Turner approached the city from the west (fol. 2) before moving to Sunningwell (fol. 17) and returning to Oxford briefly to leave by the London road past Nuneham Courtenay (ff. 87v, 88). These are merely rapid notes, and not intended for anything more than to satisfy the artist's innate need to sketch.

During the 1830s, however, he revisited the city several times, and produced three finished watercolours intended for engraving, two for the project most preoccupying him at the time, the *Picturesque Views in England and Wales*.

The origins of the series are given in a letter of 1825 from Turner's old associate, the engraver Charles Heath, to the banker, Dawson Turner, in which he boasts that,

*I have just begun a most splendid work from Turner the Academician. He is making me 120 Drawings of England and Wales – I have just got four and they are the finest things I ever saw they cost me 30 Gins each … The Drawings, what is very unusual they will yield a Profit as much as the Plates … any one who has seen them says it will be the best and most lucrative speculation ever executed of that description.[2]*

The work was to be published by Hurst and Robinson, who were to put up all the capital and receive half the drawings. Unfortunately, the publishers went bankrupt in January 1826 following the national collapse in the previous month, and work was delayed. The first part, comprising four plates, was issued in March 1827 by a different publisher, Robert Jennings and Company, and, although Heath retained an interest in the project, he shared it with a succession of publishers, and the series was never completed for want of capital. Eventually, twenty-four parts appeared, the last in 1838, and the series was a financial failure for all concerned.

Turner's visit to Oxford in the autumn of 1830, probably in September–October, was one stage in a tour of the Midlands recorded in the so-called 'Kenilworth' sketchbook, which otherwise took in Kenilworth, Dudley, Tamworth, Lichfield, and Virginia Water, and provided material for fourteen watercolours for the *England and Wales* series.[3] Turner came through Oxford at the beginning of the tour, and made three rapid sketches of the route, all of subjects he might have chosen for a finished watercolour. The first did indeed form the basis of the published watercolour, with important modifications; the second showed the High Street from Queen's College, and the third Magdalen Bridge. The order of the sketches might indicate that he used the book at random, approaching from the east and leaving from the south. All three subjects were very familiar to

him, and had been painted or drawn several times in the 1790s.

For the view of Oxford he eventually settled on for publication in *England and Wales*, he returned to what we might call his 'old' college, Christ Church, and provided a highly topical account of the disruption in St Aldate's which rumbled on during the early 1830s.

Since its foundation, Pembroke College had occupied a relatively small plot of land on the west side of St Aldate's, behind the eponymous church, but had long cherished an ambition to construct a more imposing entrance. The only way to do this was to demolish the private houses in front of the church, and annexe Cardinal Wolsey's almshouses, which had been part of the original foundation of Christ Church. As early as the 1780s, during the general improvement of Oxford after the Mileways Act of 1771, this was thought desirable, and matters had become more urgent by the late 1820s. In 1829, the Master of Pembroke College, G. W. Hall, wrote to the Dean of Christ Church that 'the removal of the Almshouses has long been considered, I may say by the public at large, as a most desirable object; and in the present improved state of every other part of this University and city, such removal seems to be urgently called for.'[4] For not only did the north front of the almshouse obscure the newly refaced and Gothicized front of Pembroke, but it also prevented carriages from driving up to the main gate. Having resisted all overtures, Christ Church now enthusiastically agreed to 'the getting rid of an abominable nuisance'.[5] What might have had the appearance of internecine warfare between a minor college and its overpowering neighbour was given general legitimacy when the whole matter was taken up by the Commissioners for the Improvement of Oxford, who opened a public subscription for the scheme to purchase and demolish the houses in front of St Aldate's Church, and the north front of the almshouses, in order to widen the street itself.

The exact chronology of this project is difficult to determine, but it is clear that, when Turner made his original sketch in the 'Kenilworth' sketchbook, demolition of at least one of the houses in question is under way. The sketch is so summary and faint that it is difficult to decipher (and impossible to reproduce), and it is possible that, in finishing his watercolour, Turner returned to Oxford and discovered the demolition in progress at that stage, as he had done with the *High Street* for Wyatt in 1809.

The finished watercolour of *Christ Church College* (pl. 23) is fuller of incident than almost any other in the series, and one of only a handful of townscapes. The afternoon sun bathes the great front of Christ Church in golden light, while two gowned figures hurry past a table of prizes. In the roadway, carefree boys fly kites while men struggle with a waggon. On the left, the demolition is in full swing, although one man pauses to pose on his ladder. The vista is blocked by imaginary buildings closing the view, which Turner transplanted from the north side of Christ Church, where he had drawn them for Lord Mansfield, to the middle of the road. Beyond, the town dissolves in a haze of light and sky.

In spite of the difficulties with publishers and engravers, Turner continued to gather material for *England and Wales* in the later 1830s, and to produce finished watercolours and plan others. His method of working on the series was fundamentally different from that for other projects before or after, for in addition to the rapid pencil studies in his sketchbooks, he had been sporadically experimenting for some time with 'colour beginnings', very large sheets of paper broadly brushed in very dilute pure watercolour. These were intended to establish the general disposition of light and shade and physical mass, and supplemented the pencil sketches he still made.

The date of the 'colour beginnings' of Oxford subjects is impossible to establish. The only firm evidence of when Turner was next in Oxford is a rueful note in a sketchbook, which must surely have been written on the spot, complaining of the custom

at Christ Church of ringing the great bell, Old Tom, 101 times at five past nine every evening, to summon the 101 Students (Fellows) on the foundation:

*Old Tom of Christ Church*
*Oxford*

*What? is it you Old Tom that*
*Keep this row every night?*
*What? is it right that*
*you should summon us*
*to bed continually*
*all the year round?*
*Is it fair that you, Tom,*
*should thus deal with*
*us every night, [of the week]*
*July 2nd.        Tegid*
*1834*[6]

We may infer that Turner was indeed in Oxford on 2 July 1834, and found the pealing of Old Tom, the great bell from Osney Abbey in Tom Tower, disturbed a quiet summer evening when he preferred to work or converse with friends. The reference to 'Tegid' may identify one of a new generation of friends or acquaintances at Christ Church, the Welsh poet John Jones (1792–1848). The occasion of this visit is not known, but the date, one day after the commemorative Act, might suggest that Turner was in Oxford for that ceremony.

The second sketchbook used in Oxford during this period was the so-called 'Oxford' sketchbook,[7] which Finberg ingeniously dated to 1834, by analogy with the date of the above comment, and from which he constructed the hypothesis that, since the only commission Turner received for an Oxford subject was the watercolour for James Ryman (see chapter 5), he must have been visiting Ryman in 1834, and that all the remaining Oxford sketches date from this visit. There is, however, no evidence that Turner and Ryman were acquainted before the late 1830s, and good reason to date one of the sketchbooks in question to 1839.[8] The

'Oxford' sketchbook cannot be dated more firmly than *c.* 1835–8, the latter being the final date for the only completed watercolour derived from the sketches.

This sketchbook (figs. 50–55) is one of the most direct and purposeful of all those in the Turner Bequest. It consists of 29 leaves of variously coloured papers, half-bound in leather, and with the majority of the leaves blank. The pages measure 14.8 × 23.3 cm. On the inside front cover, Turner has noted various subjects, probably before he used the sketchbook, since they do not all correspond with the drawings:

*Trinity Garden        Peckwater.   Dr Barnes's Door*
*St John Garden*
*Wadham Garden*
*New College Garden*[9]

Inside, the disposition of the drawings suggests that Turner was conscientiously collecting material with the specific intention of working it up into watercolours, rather than simply recording a fleeting visit as he had done earlier. Apart from one or two obscure scenes, all the sketches are fully resolved and identifiable. The first shows the High Street from the bottom end of Queen's Lane, looking towards the spire of the University Church, and with the mass of University College on the other side. Turner then moved up the High and took the opposite view, looking down towards University College. There follows a sheet of details of buildings in the same street: University College from the Angel Inn at the top; in the centre, the western part of Queen's College, with the cupola cut neatly in half; and at the bottom, a detail of the porch of the University Church and of the gateway into Queen's. A slight general outline of the High Street is followed by a drawing of coaches, and then eight blank leaves. We may surmise that Turner stopped for refreshment, since, when he began again at the opening of ff. 15v.–16, he was looking towards Queen's from a room on the first floor of the Angel

50 *High Street*, from the 'Oxford' sketchbook , *c*. 1834–8. Tate Gallery

51 *Merton College*, from the 'Oxford' sketchbook, *c*. 1834–8. Tate Gallery

52 *Studies of Buildings in the High Street*, from the 'Oxford' sketchbook , *c*. 1834–8. Tate Gallery

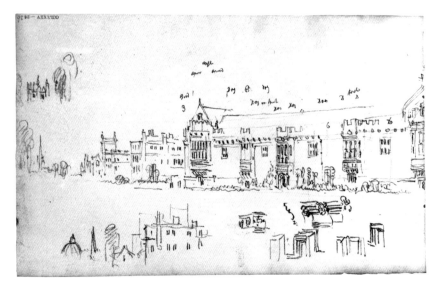

53 *St John's College*, from the 'Oxford' sketchbook, *c.* 1834–8. Tate Gallery

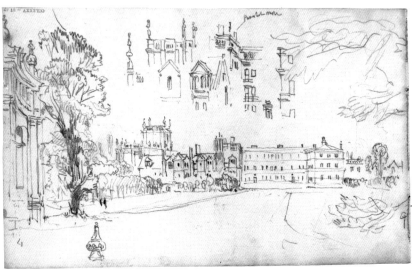

54 *Trinity College*, from the 'Oxford' sketchbook, *c.* 1834–8. Tate Gallery

55 *New College*, from the 'Oxford' sketchbook, *c.* 1834–8. Tate Gallery

Inn, where he may have been staying. This sketch shows a still more elaborate view of the whole facade of Queen's, together with subsidiary studies of the sculptures on top of the west wing, annotated *Apollo and Lyre* in the sketch. There is also a separate study of a coat of arms. The view is closed off at the left by the distinctive dome of the Radcliffe Camera, only the second time Turner had drawn it in his life.

The other side of the same opening contains a further study of the High Street, this time from the All Saints Church looking back towards the University Church, together with several illegible inscriptions. There follows a sheet of intensive studies of details (fol. 16v), before Turner moved further up towards Carfax, and looked back once again. This time, he was able to incorporate nearly all of the spire of All Saints, as well as the porch. Assuming he used the leaves of the sketchbook in order, he then went back down Oriel Street, past Canterbury Gate, to Merton Street, where he made a further elaborate study of Merton College looking west, and details of crenellation, and windows. This is the last of the street scenes, and the remainder of the sketchbook concentrates on the gardens inscribed on the cover.

The gardens of several of the colleges of Oxford had long been celebrated, notably the Botanic (or Physick) Garden, belonging to the University, and the expansive gardens of St John's College and New College. Turner had previously only drawn the gardens of Christ Church, but, in his search for new material for *England and Wales*, he no doubt felt they might make a distinctive contribution. He may also have heard of his friend, William Delamotte's, plan for an illustrated companion to Oxford buildings and gardens, published in 1843.[10]

Some time after this visit, Turner reworked each separate subject into a series of colour beginnings, one each of the gardens of New College, St John's College and Trinity College (pl. 32), and no fewer than six of the High Street (pls. 24–29).[11] While those of the gardens reflect fairly closely the pencil compositions

they were based on, the six of the High Street are all quite different, which has led one scholar to propose that they were made in two groups, ten years apart.[12] The colour beginnings were by their nature experimental, and it is preferable to see in these six sheets experiments in manipulating composition and perspective. All but one show the same basic view, looking west up the High Street, but begin and end at different points, the only constant reference being the spire of St Mary the Virgin. They cannot be placed in any logical order, and, while some compositions correspond more closely with the sketches in the 'Oxford' sketchbook, this is almost accidental. Two have figures added in the foreground, once carefully with the point of the brush in red watercolour, once rather more abstractly blocked in in grey. It is clear from the fact that this is the largest group of colour beginnings relating to a single composition, that Turner attached a great deal of importance to this new view of the High Street, and all the more strange that the other Oxford subject he completed for *England and Wales* was the only subject in the Oxford sketchbook for which a colour beginning does not survive.

*Merton College* (pl. 22) shares many characteristics with the published watercolour, *Christ Church College*, and its composition would have made it an ideal pendant. It was a subject Turner had known in his youth, and one frequently depicted by other artists. The gatehouse was completed in 1418, and the façade to the east was refaced in 1836–8, and details suggest that Turner had depicted the end of that process. Workmen in the road tidy up in the evening sunlight, while two gowned figures discuss some abstruse point and a milkmaid scurries past. The street lends itself to the distortion in perspective, now wholly incorporated in Turner's imaginary topography.

With *Merton College*, Turner ended his work on *Picturesque Views in England and Wales*. It was not engraved, nor was it sold, but retained by the artist, the only completed example for the project on which he had spent nearly thirteen years.

# 5

# Turner's Last View of Oxford

Turner was so overwhelmed with work and travel in the 1830s, that his recorded visits to Oxford were far less frequent. Nor does he seem to have had any remaining friends or family he wanted to visit regularly. On his last visit in *c.* 1839, however, he painted his last and most magnificent watercolour of the city, effectively summarising his work of the previous four decades.

The only contemporary account of the view of *Oxford from North Hinksey* is given by the son of the man who was eventually to engrave it, Edward Goodall. Frederick Goodall remembered that,

*My father was commissioned by a publisher to engrave a large drawing after Turner of 'A distant view of the city of Oxford'. One of the dons of a College accompanied Turner to the spot from which they wanted the drawing made. The first day he went up he said, 'This won't do; I must come up again'; but a second visit proved fruitless. When they got up to the hill on the third day, a thunderstorm was coming on, with dark purple clouds over the city, bringing out all the fine buildings into light against it. 'This will do', said Turner, 'I don't want to make a sketch; I shall remember this'. And certainly he knew every building in Oxford, for he had drawn them when he was a boy. But when the plate was being engraved, the publisher asked my father to go down to the spot and look at the view. He took me with him, with my sketch-book to make the drawings of the distant buildings, and put them in their proper places, for Turner was a little careless about that. I went down and made the drawings to help my father in his engraving. But, I thought, when I looked at the city, that it was not as beautiful as Turner had made it.*

*The effect was extremely fine with the dark purple clouds above. I had never seen the city of spires and towers under that aspect.*[1]

Unfortunately, we cannot treat this as anything more than a charming anecdote, which is misleading in several respects and untrue in others.

Turner's watercolour was commissioned by an Oxford businessman, James Ryman.[2] Like his rival, James Wyatt, Ryman began his career as a carver and gilder, and is listed as such in the trade directories. He set up his business in 1816 or 1819,[3] occupying a shop in St Aldate's, before moving to much more spacious and fashionable premises at 24–5 High Street in 1823, advertising himself as 'Carver, Gilder, Picture Frame and Looking Glass Manufacturer.'[4] From these traditional crafts, he no doubt progressed to selling pictures and prints, but his only significant venture as a publisher during the 1830s was the volume of *Illustrations of Oxford; being select views of the colleges, halls, and other public edifices, including the most recent additions and alterations, with historical and descriptive letterpress*, on the title page of which he described himself as 'James Ryman, printseller'. This was a publication of some pretensions, of a handsome size, including 38 plates, dedicated to Queen Adelaide, and apparently intended to be the first of several volumes. The engravings, mostly by George Hollis, reproduced watercolours by fashionable London artists such as Boys and John Skinner Prout, as well as the local topographers, J. C. Buckler, Joseph and Frederick Nash, and Thomas and George Hollis. As might be expected for this first venture into publishing, it was protracted and

unfinished. One watercolour by Boys is dated 1832,[5] although Hollis's engraving after it is dated 1839; and the other engravings range in date from 1 November 1832 to 16 June 1841, with a majority dated 1836. Once again, it is possible to speculate that Ryman had originally hoped to engage Turner on this project, that some of the sketches and colour beginnings usually associated with *England and Wales* may have been preparations for work for Ryman's volume, and that the single large plate of *Oxford from North Hinksey* was a compromise.

The particular point from which this view was taken has been long mistaken. Despite the title on Goodall's engraving, it was known at Manchester as *Oxford from Headington Hill*, until Kenneth Clark wrote from the National Gallery to suggest that it showed the view from Boar's Hill, to the south-east of Oxford.[6] In fact, the watercolour shows the view from the south-west of Oxford, from a hillside above North Hinksey: the tower of the village church is visible through the trees at the far left, while the strange building with buttresses to its right is the conduit house, which marked one end of Otho Nicholson's scheme for bringing water to the city of Oxford in the 1630s. This was exactly the prospect which had been recommended by William Combe, describing a plate after Farington in his *History of the River Thames* in 1794:

*The country to the right consists of meadows, with fine bold sloping ground beyond them, agreeably sprinkled with trees, which gradually falls from the height of Cumnor Hurst to the village of Hinksey; known by its ferry over a principal branch of the river. On the descent of this verdant declivity is Sweetman's farm … As the city and surrounding country is seen from a very superior advantage at this spot, we know not how to reconcile the circumstance, unless it be from the evident difficulty of execution, that this should be the only view of Oxford, as far as we could learn, that has been taken from this very commanding and beautiful station.*[7]

This view was indeed unusual when Farington took it, although there were precedents, notably Samuel Buck's very grand prospect of *Oxford from the South West* of 1740. Turner probably knew Farington's original drawing of the view, or Stadler's aquatint after it, but in recent years, the vantage point had become commomplace: W. M. Wade, for example, in his *Walks in Oxford*, wrote that from this point, 'Oxford is seen to great advantage, rising like the queen of the vale from the bosom of a thick grove, between which and the spectator the Isis rolls her mazy waters towards the east.'[8]

Turner's preparatory studies are contained in the 'Moselle and Oxford' sketchbook, generally dated to 1834 following Finberg, but convincingly assigned to *c.* 1839 by Cecilia Powell.[9] There was apparently a tradition in Oxford, which cannot be confirmed or refuted, that Turner stayed with Ryman while preparing for and painting the watercolour; this was more probably in 1839 than 1834.[10] The sketches served as reminders rather than new explorations, and, apart from summary studies of Magdalen Bridge, there are two main groups, one of Oxford from Headington Hill, and the other of the city from North Hinksey.[11] The watercolour synthesises the latter group.

In keeping with his common but not invariable practice at this date, Turner produced a large 'colour beginning' of the subject (pl. 30), essentially similar to the finished watercolour, though radically simplified into a theatrical set, and with a slightly compressed middle distance. In the final watercolour (pl. 31, fig. 56), the sinuous curve of the river meanders towards the city, where the varied spires, each carefully delineated and accurately positioned, seem to reflect Turner's fascination with them, from the radical neo-classicism of the Radcliffe Observatory on the far left, past the mediæval tower of the castle, to the spires of the University, the Radcliffe Camera, All Saints, St Mary's, Tom Tower, Merton, the Cathedral, and Magdalen Tower on the extreme right. The variety sums up Oxford architecture as Turner knew it, not

simply late gothic, but including outstanding examples of most periods.

The main difference in the watercolour for Ryman is the addition of figures, two dons at the right, and a large group of women harvesting corn in the foreground. In the centre, one of the women talks to a foreman or farmer on horseback. The tradition that the dons followed Turner on his long walk out of Oxford to watch him sketch is scarcely credible.[12] Certainly, their absurdity was recognised as early as 1853, by a graduate of Durham University, Edward Bradley alias

Cuthbert Bede, who wrote in his celebrated novel, *The Adventures of Mr. Verdant Green, an Oxford Undergraduate*, that the hero, who was afraid to divest himself of his cap and gown when out strolling up Headington Hill, 'might almost have been taken for the original of that impossible gownsman who appears in Turner's well-known "View of Oxford, from Ferry Hincksey", as wandering – Remote, unfriended, solitary, *slow* in a corn-field, in the company of an umbrella!'[13]

The women harvesting, arranged into those work-

56  *Oxford from North Hinksey*, c. 1839. Manchester City Art Gallery (cat. no. 66a)

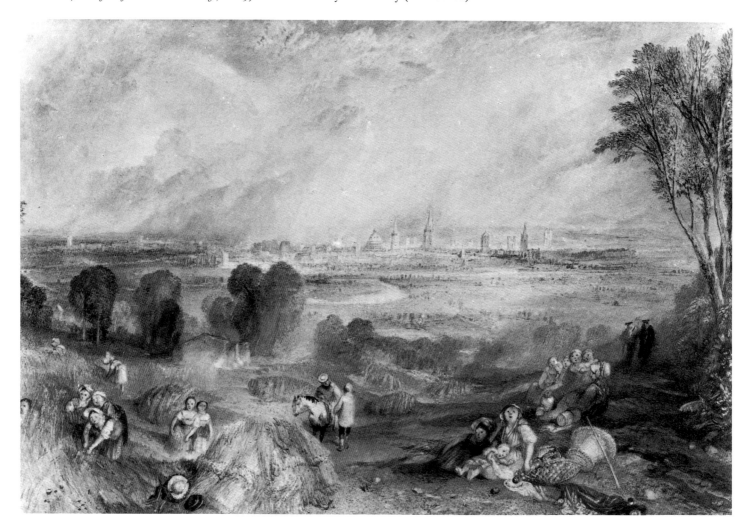

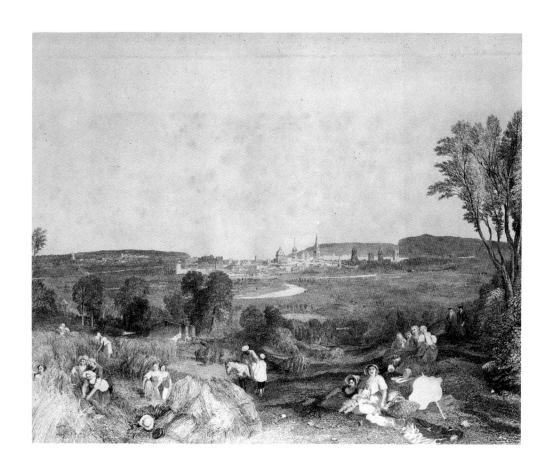

57 Edward Goodall
after Turner, *Oxford from
North Hinksey*, state I.
Ashmolean Museum
(cat. no. 66b)

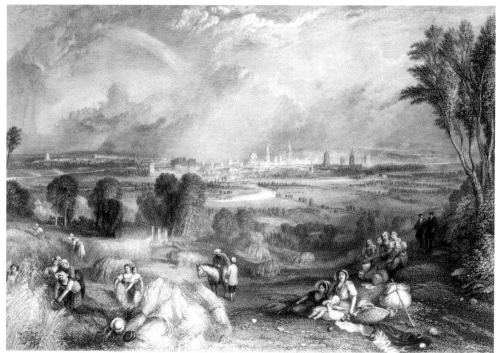

58 Edward Goodall
after Turner, *Oxford from
North Hinksey*, state IV.
Ashmolean Museum
(cat. no. 66c)

ing on the left, and others resting on the right, are close relations of most of the figures inserted into Turner's large works of the 1840s. It has been suggested that in this watercolour, Turner is making social comment about the divisive effect of enclosures around Oxford,[14] although it is difficult to see whether the fields are indeed enclosed. In reality, the topical reference in the watercolour, but not in the preliminary sketches, was probably taken by contemporaries to denote the grandiose schemes by the landowner, the fourth Earl Harcourt, to establish a model village and park in the area, much as his ancestor, the first Lord Harcourt, had done at Nuneham Courtenay.[15] Nothing came of the scheme, but the reapers may have been viewed as an elegy for the old system fast disappearing.

*Oxford from North Hinksey* was engraved on steel by Edward Goodall (figs. 57, 58), one of the most dedicated of the small band of Turner's engravers, and one of the most experienced, having worked on numerous vignettes during the 1830s. This was his first large plate, and it effectively translates and refines the watercolour and makes it more acceptable to a discriminating public. He misunderstood the vague indication for the tower of North Hinksey Church, giving it arcaded decoration where it has none. More importantly, he prettified the human figures, so that they no longer have the bestial appearance Turner favoured, but are elegant enough to be young ladies at play. Turner did not object to this, but was concerned that the sheaves of corn should be properly depicted. He wrote on one proof, 'I must beg of you to be particular in filling in the lines in the Corn Sheaves. Do not cross them like [sketch] but [sketch], leaving bright bits, and if you can cut into the [sketch] ends without reducing the Light [sketch] for a few … so much the better'.[16]

With this last watercolour, Turner completed his exploration of Oxford, which had lasted over fifty years. After two oil paintings and nearly forty watercolours, he returned to one of the views he had known as a child, from the hills, with the spires and domes gleaming in the distance, dramatically highlighted against a stormy sky. To one of the many native artists whom he could have met in Oxford, from Malchair in the 1780s to Delamotte and William Turner in the 1830s, he remained a tourist, exploring from the outside the most notable monuments in the city. Yet many of his works remain the most memorable images of Oxford ever produced, and he was able to apply the lessons he learnt here throughout his life. It can be no accident that his characteristic method of sketching almost any town on his tours was to circle it and draw it from the high points around it, as he had drawn Oxford from Boar's Hill when he was fourteen. His poetic distortions may not please the antiquary, and his topographical inaccuracies certainly annoyed his patrons at the Clarendon Press. But Turner's oils and watercolours and the prints derived from them are the pictorial equivalent of Matthew Arnold's poetry, in which Oxford was to be immortalised as

*That sweet city with her dreaming spires,*
*She needs not June for beauty's heightening,*
*Lovely all times she lies, lovely tonight!*

'Thyrsis', 1867

# Notes

## PREFACE

1 Andrew Wilton, 'Turner and the Sense of Place', *Turner Studies*, VIII/2 (1988), pp. 26–32 (26).

## INTRODUCTION

1 *Gentleman's Magazine*, LI (1781), p. 448.
2 William Combe, *An History of the River Thames*, I (London, 1794), pp. 120–1.
3 See Graham Midgley, *University Life in Eighteenth-Century Oxford* (New Haven and London, 1996); and the relevant volumes of *The History of the University of Oxford*, V, *The Eighteenth Century*, ed. L. S. Sutherland and L. G. Mitchell (Oxford, 1986), and VI, *Nineteenth-Century Oxford*, Part 1, ed. M. G. Brock and M. C. Curthoys (Oxford, 1997).
4 See Howard Colvin, *Unbuilt Oxford* (New Haven & London, 1983), pp. 60–77; *Nicholas Hawksmoor and the Replanning of Oxford* (exh. cat. by Roger White; R.I.B.A. and Ashmolean Museum, 1997–8).
5 Mary Shelley, *Frankenstein*, ed. M. K. Joseph (Oxford, 1998), p. 160.
6 See John Dougill, *Oxford in English Literature: The Making, and Undoing, of 'The English Athens'* (Ann Arbor, 1998); and Judy G. Batson, *Oxford in Fiction: An Annotated Bibliography* (New York, 1989).
7 Farington, *Diary*, 1 August 1800 (ed. Garlick and Macintyre, IV, p. 1425).
8 Farington, *Diary*, *loc. cit.*
9 *Gentleman's Magazine* (1790) I, p. 1174.

## CHAPTER I

## Turner's Early Work at Oxford

1 *Notes by Mr Ruskin on his Drawings by the late J. M. W. Turner, R.A. ... exhibited at the Fine Art Society's Galleries* (London, 1878), p. 7.
2 Youngblood 1984 deals only with the architectural subjects.
3 The most authoritative (and best written) biography is now Hamilton 1997, superseding Finberg 1939, and to be supplemented for the genealogical details by Whittingham 1999.
4 'A Clergyman has complained of T neglecting an Uncle, a Butcher, who once supported him for 3 years.' Farington, *Diary*, 12 May 1803 (ed. Garlick and Macintyre, VI, p. 2028).
5 The genealogical complications are worked out in Whittingham 1999, II, pp. 19–22.
6 Joseph Marshall married first Ann Haines, who died in 1798, and second, her sister, Mary Haines, also in 1798. The second marriage took place at Brentford, where both spouses were resident (see Whittingham 1999, *loc. cit.*).
7 British Library, Add. MS 50118, fol. 67. Regret-

tably, the pencil lines make the map too faint to reproduce here. It is also described by Finberg, 1939, p. 276.
8 The copy is now in Brentford Public Library. One of the plates was of Folly Bridge, Oxford.
9 Petter 1974, pp. 75–6. Turner may very well not have known of Rooker's authorship.
10 British Museum; see Rotha Mary Clay, *Samuel Hieronymus Grimm of Burgdorf in Switzerland* (London, 1951), p. 77, pl. 87.
11 For examples, see Oxford 1998, nos. 6, 11–13, 34.
12 Farington, *Diary*, 20 January 1799 (ed. Garlick and Macintyre, IV, p. 1141).
13 Colvin, *Dictionary*, p. 637.
14 T.B. II-6v., 7.
15 In a letter to Ruskin of 30 May 1860, quoted in Finberg 1939, pp. 27–8.
16 Indianapolis Museum of Art; Wilton 1979, no. 10.
17 Finberg 1939, p. 21.
18 Benedict Nicolson, *Courbet: The Studio of the Painter* (London, 1973), p. 33.
19 Gage 1980, no. 2.
20 William Alfred Delamotte (1775–1863).
21 As Wilton 1987, p. 24 notes.
22 See *D.N.B.* He matriculated from Christ Church in 1764, was successively admitted B.A. (1768), M.A. (1771), B.D. (1777), and D.D. (1781).
23 I am grateful to Mrs Judith Curthoys for this information. In Oxford 1998, no. 32, I supposed that the 'Mr Jackson' mentioned on the verso of Malchair's drawing was either William or Thomas Jackson (1745–1797); I am now inclined to believe that Cyril Jackson was both Malchair's pupil and Turner's patron. Malchair's drawing was sold at Sotheby's, 31 March 1999, lot 10.
24 Noted by Gage 1980, p. 21, n. 2; see T.B. LXXVI; Finberg 1909, I, p. 207.
25 Youngblood 1984, p. 7.
26 *Tom Tower from the West*, December 1781, sold Sotheby's, 15 June 2000, lot 202.
27 Exh. Agnew's, '104th Annual Exhibition of Watercolours and Drawings', 1977, no. 17; Wilton 1979, no. 38.
28 Wilton 1979 and Youngblood 1984 describe the tracing as a preparatory study for the water colour. The latter recognises that it has been traced from another work, and curiously that the paper 'accidentally slipped' in the making.
29 See Andrew Wilton, 'The "Monro School" Question: Some Answers', *Turner Studies*, IV/2 (1984), pp. 8–23.
30 30 December 1794 (ed. Garlick and Macintyre, I, p. 283).
31 Farington, *Diary*, 12 November 1798 (ed. Garlick and Macintyre, III, p. 1090).

32 Walter Thornbury, *The Life of J. M.W. Turner, R.A.*, 2 vols (London, 1862), I, p. 67.
33 T.B. XXVIII-J, K, the latter repr. in *Turner Society News*, no. 67 (August 1994), p. 13.
34 Rawlinson 1913, nos. 813–16.
35 See John Cornforth, 'Scone Palace, Perthshire, II', *Country Life*, 18 August 1988.
36 Still in the family collection at Scone Palace; the unhappy circumstances of its acquisition are related by Farington, *Diary*, 1 June 1806 (ed. Cave, VII, pp. 2775–6). On the 3rd Earl, see Julius Bryant, *The Iveagh Bequest, Kenwood* (London, 1990), pp. 65–6.
37 T.B. XXVI-97.
38 The sketch is in the Bodleian Library, G.A. Oxon. a. 88b, p. 42; see Petter 1974, p. 80.
39 Tate Gallery, T.B. CXIX-E; described by Finberg 1909, I, p. 325, as 'Façade of late Renaissance Building' and correctly identified by Youngblood 1984, p. 12.
40 Once again, I am grateful to Mrs Curthoys for this information.
41 Christ Church Archives, MS Estates 144, fol. 27, 'A Valuation of the Cullumns Wains' &C taken from the End and Doorway of Cᵗ Cʰ Hall Sep 1799'. This must be the beginning of the process of refurbishment of the hall generally dated to 1801–4.
42 *Malton's Oxford*, pl. 6.
43 Noted by Youngblood 1984, p. 5.

## CHAPTER 2

## The Designs for the *Oxford Almanack*

1 See Rawlinson 1908, Nos . 1–31.
2 Wilton 1979, nos. 196–203.
3 The history of the *Oxford Almanack* was begun by Bell 1904, continued by Herrmann 1968, and exhausted by Petter 1974.
4 On which see most recently, *Les Effets du soleil: Almanachs du règne de Louis XIV* (exh. cat. by Maxime Prèaud, Louvre, Paris, 1995).
5 See Petter pp. 73–8, and Patrick Conner, *Michael Angelo Rooker 1746–1851* (London, 1984), pp. 106–15.
6 Orders and Accounts (O.U.P. Archives), II, for 1795.
7 Orders and Accounts, II, p. 14.
8 *D.N.B.*
9 The Delegates in 1797–8, when Turner received the commission, were Dr John Randolph; Dr David Hughes, later Principal of Jesus College; Dr Cyril Jackson, Dean of Christ Church; Dr George Williams; Dr John Parsons, Master of Balliol; Dr Martin Routh, President of Magdalen; and the Vice-Chancellor, Dr Michael Marlow, President of St John's. They also commissioned Turner's later watercolours, save

that the Vice Chancellor was succeeded in 1802 by Dr Whittington Landon, Provost of Worcester. See the unpublished MS of 'Press Records' compiled by R.W. Chapman in 1939 (O.U.P. Archives).

10 In 1807, for example, 1950 copies of the *Almanack* were printed, of which 1700 were sold and the remainder given away; Orders and Accounts, II, for 1806–7.

11 1768; Petter 1974, p. 73.

12 The pasture was leased at this period to a publican.

13 *England Illustrated*, 2 vols (London, 1764), II, p. 163.

14 See Cecil S. Emden, *Oriel Papers* (Oxford, 1948), pp. 158–61.

15 See cat. nos. 8–9.

16 Orders and Accounts, II, for 1802.

17 See Charles Avery, *Giambologna: The Complete Sculpture* (London, 1993), pp. 75–7 and no. 3.

18 He was a close friend of Malchair's; see Oxford 1998, nos. 19, 30 and 31.

19 Orders and Accounts, II, p. 205.

20 *A New Pocket Companion for Oxford: or, Guide through the University*, new edition (Oxford, 1797).

21 Oxford 1998, no. 69.

22 Rawlinson 1908, no. 18.

23 Tate Gallery, T.B. XLVII-37.

24 Orders and Accounts, II, p. 186.

25 See John Jones, 'Sound Religion and Useful Learning: the rise of Balliol under John Parsons and Richard Jenkyns, 1798–1854', in *Balliol Studies*, ed. John Prest (London, 1982), pp. 89–123; and H.W. C. Davis, *A History of Balliol College* rev. R. H. C. Davis and R.W. Hunt (Oxford, 1963).

26 Cordeaux and Merry 1968, nos. 312–13.

27 Dayes must refer to the *Almanack*. Delamotte perhaps to a drawing, since there are no prints by him.

28 See cat. no. 50a.

29 Orders and Accounts, II.

## CHAPTER 3
### Two Oil Paintings for James Wyatt

1 Sold at Sotheby's, 8 June 1999, where bought by Lord Lloyd-Webber. See also *Millais Portraits* (exh. cat. by Peter Funnell and Malcolm Warner, National Portrait Gallery, 1999), no. 4.

2 Letter to James Wyatt junior on the death of his father, March 1853, untraced; transcript in Bryson Papers, Department of Western Art, Ashmolean Museum. See also J. G. Millais, *The Life and Letters of Sir John Everett Millais, President of the Royal Academy*, 2 vols (London, 1899), I, p. 34.

3 For a general biography, see Hugh Wyatt Standen, 'Alderman James Wyatt, of Oxford. 1774–1853', unpublished MS, Bryson Papers, Department of Western Art, Ashmolean Museum.

4 Malcolm Graham, *Oxford City Apprentices* (Oxford Historical Society, 1987), no. 2887.

5 See *Catalogue of the choice Collection of Pictures, Drawings, Prints, and Objects of Art, of the late Mr. Wyatt, of Oxford*, Christie's, 4–6 July 1853, lots 271–283, copper and steel plates.

6 Rawlinson, 1908, p. 37.

7 *Jackson's Oxford Journal*, 26 March 1853.

8 Wyatt sale, lot 283g; the series is printed in Gage 1980, nos. 24–34, 41, 44–6.

9 A sketch of the Pantheon, Oxford Street, includes the name of 'Wyatt Carver and Guilder' among the inscriptions; Tate Gallery, T.B. CXCV-156.

10 Tate Gallery; Butlin and Joll 1984, no. 97.

11 Rawlinson 1908, I.

12 See the announcement in *Jackson's Oxford Journal* for that day.

13 C. P. Moritz, *Travels through various Parts of England in 1782*, quoted in Brown 1990, p. 95.

14 Combe 1794, p. 120.

15 Gage 1980, p. 43.

16 See chapter 1, note 7. The vantage point is in the field to the west of the road from South Hinksey to Boar's Hill, at the bottom of Hinksey Hill near the bus stop.

17 Basil Hunnisett, *Steel-engraved Book Illustration in England* (London, 1980), p. 39.

18 The tradition in the Wyatt family that this copy was lent to the engravers to preserve the original from damage cannot be true; see Standen, p. 2. It is now in a private collection.

## CHAPTER 4
### The Watercolours for *Picturesque Views in England and Wales*

1 Tate Gallery, T.B. CXCVIII.

2 The most accurate history of the project, from which this account is taken, is Shanes 1990, which supplements Shanes 1979 and Shanes 1984.

3 Tate Gallery, T.B. CCXXXVIII.

4 Christ Church Archives, MS Estates 142 fol.175, quoted in A. H. Lawes, 'Historical Notes on the Almshouse', unpublished MS, Pembroke College Archive, 18/12/15, unpaginated [p. 4].

5 Christ Church Archive, MS Estates 142, fol. 176, quoted in Lawes, *loc. cit.*

6 Transcribed in Cecilia Powell, 'Turner, Tom and Tegid', *Turner Society News*, 74 (December 1996), pp. 14–15. Dr Powell devises an ingenious explanation for the note, arguing that it does not necessarily confirm Turner's presence in Oxford on this date. Even if the handwriting is that of Tegid, not Turner, the likelihood of Turner's being in Oxford is strong.

7 T.B. CCLXXXV.

8 Cecilia Powell, *Turner's Rivers of Europe: The Rhine, Meuse and Mosel*, exh. cat., Tate Gallery, London, 1991–2, p. 46.

9 Finberg misreads several of these entries.

10 William Delamotte, *Tour of the Colleges and Gardens of Oxford* (Oxford, 1843).

11 As Eric Shanes so brilliantly identified in London 1997. Youngblood's assertion (p. 19) that Turner's preoccupation with the High Street dated from the time he painted it for Wyatt is, incidentally, untrue.

12 Lyles in London 1992.

## CHAPTER 5
### Turner's Last View of Oxford

1 Frederick Goodall, *Reminscences* (London, 1902), pp. 54–5, quoted in Shanes 1981.

2 See the obituary in *Jackson's Oxford Journal*, 30 October 1880, p. 5. He was born on 29 March 1794, and died on 25 October 1880.

3 According to trade labels still found on the firm's frames, it was established in 1816. However, Ryman was admitted a freeman of Oxford by special act on 6 September 1819; this would have enabled him to set up his own business. Rawlinson 1908, p. 37, claims that he was Wyatt's successor, but this is true only in the loosest sense: James Wyatt the Younger continued his father's business until his death in 1882, after which Ryman did indeed become the leading print publisher in Oxford.

4 See the advertisement in *Jackson's Oxford Journal*, 9 August 1823. The shop in the High can be seen in photographs by Minn taken in c. 1910 in the Bodleian Library, G.A. Oxon. a. 65, p. 61. It was pulled down to make way for the High Street facade of Brasenose College in 1909–11.

5 *Jesus College from the Turl*, sold Sotheby's, 26 November 1998, lot 61, bought Jesus College.

6 Letter to the gallery of 21 March 1934.

7 William Combe, *An History of the River Thames*, I (London, 1794), p. 103.

8 W. M. Wade, *Walks in Oxford*, 2 vols (London and Oxford, n.d.), II, p. 335.

9 Cecilia Powell, *Turner's Rivers of Europe: The Rhine, Meuse and Mosel* (Tate, 1991–2), p. 46.

10 Recorded by Henry Minn, in Bodleian Library, MS Top. Oxon. d. 499, fol. 20.

11 T.B. CCLXXXIX, ff. 25r & 25v, 17v–18, 21v, 24.

12 Recorded by Rawlinson 1913, no. 651.

13 Cuthbert Bede, *The Adventures of Mr Verdant Green, an Oxford Undergraduate* (Oxford, 1982), p. 86.

14 In Memphis etc 1997–8, no. 55. For this subject in general, see Payne 1991.

15 See John Hanson, *A Thousand Years: A Study of the Interaction between People and Environment in the Cumnor, Wytham, & North Hinksey Area of (former) North Berkshire*, privately printed, 2 vols (Oxford, 1996), I, pp. 151–3; II, pp. 234–5 (map of fields).

16 Rawlinson 1913, no. 651, engraver's proof; offered at Sotheby's, 5 December 1996, lot 198, bought in.

# Summary Catalogue

Titles for the engraved works are taken from the engravings. Dimensions are given in millimetres, height before width; for engravings, the plate mark is measured. T.B. refers to the Turner Bequest to the nation, now housed in the Tate Gallery.

**1** [fig. 4]
*North West View of Friar Bacon's Study, &c.*
1787
pen and black ink and watercolour, 308 × 432
signed and dated lower right, *W Turner 1787*
PROV: T.B. I-A
Tate Gallery (D00001)
EXH: London 1980, no. 1
LIT: Tyrrell-Gill 1904, pp. 16–17; Finberg 1909, I, p. 1 (as after Dayes?); Finberg 1910, p. 9; Finberg 1939, p. 14; Petter 1974, p. 76; Wilton 1979, no. 5 (as after Dayes); Youngblood 1984, p. 4 (as after Rooker); Brown 1990, p. 94; Hill 1993, pp. 4–5
Copied from the *Oxford Almanack* for 1780, designed and engraved by Michael 'Angelo' Rooker

**2** [pl. 2]
*A View of the City of Oxford*
c. 1787–8
pen and Indian ink and watercolours over pencil, 316 × 463 (image), 358 × 510 (sheet)
inscribed, *A View of the CITY of OXFORD*

PROV: T.B. III-B
Tate Gallery (D00046)
LIT: Finberg 1909, I, p. 5 (c. 1789); Youngblood 1984, p. 5 (c. 1790); Hill 1993, pp. 9–10

**3** [fig. 5]
*Distant View of Oxford from the Abingdon Road*
1789
pen and black ink and watercolours over pencil, 246 × 434 (image), 307 × 488 (sheet)
PROV: T.B. III-A
Tate Gallery (D00047)
LIT: Finberg 1909, I, p. 5; Finberg 1910, p. 13; Finberg 1939, pp. 15–16; Youngblood 1984, p. 5; Hill 1993, pp. 6, 9
Based on a sketch in the 'Oxford' sketchbook (T.B. II, ff. 6 v.–7)

**4** [pl. 1]
*Distant View of Oxford from the South*
1789
pen and black ink and watercolours over pencil, 195 × 250
MS label on backboard, *View of Oxford by J M W Turner R A. when quite a boy*
PROV:[1] given by the artist to Miss Narraway, Bristol; Miss [Ann] Dart; Miss Mary Short; Mrs Bartle; Phillips, 9 November 1999, lot 19
Lent by Mr and Mrs P. A. J. Abbott
LIT: J. R. Piggott, 'Turner's Early

View of Oxford', *Turner Society News*, 84 (March 2000), p. 5

**5**
*Oxford from Headington Hill; Sunset*
c. 1790
pencil and watercolours, 208 × 265
PROV: Andrew Wyld
Lent from a private collection

**6** [fig. 7]
*Christ Church from Merton Fields*
1790–1
pen and ink and watercolours, 272 × 332 (image), within a delineated border, 294 × 385 (sheet)
signed, *William Turner Delt* and inscribed in margin, *CHRIST CHURCH / OXFORD*
PROV: T.B. VIII-A
Tate Gallery (D00115)
EXH: Lisbon 1973, no. 1; London 1975, no. 1; Athens 1981, no. 2
LIT: Finberg 1909, I, p. 12; Youngblood 1984, pp. 5–6

**7** [fig. 8]
*Tom Tower, Christ Church*
c. 1793
pen and brown and grey inks and watercolours over pencil, 271 × 215
PROV: T.B. XIV-B
Tate Gallery (D00155)
EXH: Lisbon 1973, no. 2; London 1989/1, no. 4
LIT: Finberg 1909, I, p. 18; Finberg 1939, pp. 30–1; Youngblood 1984, p. 9

8 [pl. 3]
*St Mary's Church and the Radcliffe Camera from Oriel Lane*

c. 1793
pencil and watercolour with some pen and brown ink, 270 × 215
signed, *Turner delin.t*
PROV: T.B. XIV-C
Tate Gallery (D00156)
EXH: London 1974–5, no. 8; The Hague, 1978, no. 2; Mexico City 1979, no. BM2
LIT: Finberg 1909, I, p. 18 (1793); Youngblood 1984, p. 5

9 [fig. 10]
*St Mary's Church and the Radcliffe Camera from Oriel Lane*

c. 1795
pencil and watercolour, 528 × 382
PROV: T.B. XXVII-X
Tate Gallery (D00685)
EXH: London 1974–5, p. 34, no. 9
LIT: Finberg, 1909, I, p. 56 (1795); Youngblood 1984, p. 5; Hamilton 1997, pp. 23–4

10 [fig. 11, not exhibited]
*The Radcliffe Camera from Brasenose College*

c. 1793
pencil and touches of wash, 273 × 206
inscribed lower centre, *Radcliffe Library Oxford*
PROV: presented by Herbert Powell through the National Art Collections Fund, 1967
Tate Gallery (T01020)

11 [fig. 13, not exhibited]
*Kill Cannon Passage, Christ Church*

c. 1793
pencil, 271 × 210
inscribed lower right, *Entrance to Christ Church from Peckwater Colledge OXON*

PROV: T.B. XI-C
Tate Gallery (D00128)
LIT: Finberg 1909, I, p. 14 (1792)

12 [fig. 12, not exhibited]
*Merton College Chapel from the East*

c. 1793
pencil and touches of watercolour, 239 × 212
inscribed lower right, *Merton Colledge*
PROV: T.B. XI-D
Tate Gallery (D00129)
LIT: Finberg 1909, I, p. 14 (1792)

13 [fig. 15]
*Magdalen Tower and Bridge*

c. 1793
pencil, 263 × 210
inscribed along lower edge, *Magdalen Colledge and Bridge* and *Water Dark*
PROV: T.B. XI-B
Tate Gallery (D00127)
LIT: Finberg 1909, I, p. 14 (1792); Youngblood 1984, p. 7

14 [pl. 5]
*Magdalen Tower and Bridge*

1794
watercolours over pencil, 286 × 222
dated and signed, *Turner 1794*
PROV: Dr Thomas Monro; Christie's, 26 June 1833, lot 127, to Boys; Frederick Broderip; Christie's, 6 February 1872, lot 621, to Agnew; A. G. Kurtz; Christie's, 11 May 1891, lot 193, to Agnew; purchased, 1891, with a fund presented by the Guarantors of the Manchester Jubilee Exhibition of 1887
Whitworth Art Gallery, University of Manchester (D.6.1887)
EXH: Manchester 1984, no. 4; Memphis 1997–8, no. 7
LIT: Wilton, 1979, no. 69

15 [fig. 16]
*Magdalen Tower and Bridge*

c. 1794
watercolours over pencil, 285 × 224
PROV: John Henderson, senior; John Henderson, junior, by whom bequeathed, 1878
Lent by the Trustees of the British Museum (1878-12-28-39)
EXH: no. 300; London 1980, no. 8
LIT: Binyon 1898, no. 2; Wilton, 1979, no. 70 (?1794); Youngblood 1984, pp. 8–9

16 [pl. 7]
*Christ Church from the South*

c. 1794
watercolours over pencil, 321 × 426
signed lower right, *Turner*
PROV: John Henderson, senior; John Henderson, junior, by whom bequeathed, 1878
Lent by the Trustees of the British Museum (1878-12-28-42)
EXH: London 1969, no. 309; London 1975, no. 6; London 1980, no. 9
LIT: Binyon 1898, no. 18; Wilton, 1979, no. 71 and p. 35 (c. 1794); Youngblood 1984, p. 10

17 [pl. 8]
*Christ Church Cathedral from the Canons' Garden*

1794
watercolours, 395 × 320
signed and dated lower right, *Turner 1794*
PROV: Messrs Thomas McLean, Haymarket; Revd E. S. Dewick; his widow, by whom presented, 1918 (no. 917)
Lent by the Syndics of the Fitzwilliam Museum, Cambridge (no. 917)
EXH: Cincinatti 1986, no. 4; Cambridge 1994, pp. 62–3

LIT: Cormack, no. 4 (with full bibliography); Wilton, 1979, no. 72; Youngblood 1984, p. 11

## 18 [pl. 6]
*Founder's Tower, Magdalen College*

c. 1794
watercolours over pencil, 357 × 263
signed, lower right, *W. Turner*
PROV: Agnew's; bt on 17 February 1902 by George Salting,[2] by whom bequeathed, 1910
Lent by the Trustees of the British Museum (1910-2-12-286)
LIT: Wilton, 1979, no. 68 (c. 1794); Youngblood 1984, pp. 8–9

## 19a [pl. 9]
*Christ Church Cathedral from the Dean's Garden*

c. 1795
pencil and pen and ink and watercolours, 203 × 273
PROV: Sir Henry Stucley Theobold, K.C.; Robert Tronson; Christie's, 2 March 1976, lot 123
Lent from a private collection
LIT: Wilton, 1979, no. 133 (c. 1795)

## 19b
R. G. Reeve after Turner
*Christ Church Cathedral, Oxford*

colour aquatint
inscribed, *Turner R.A. del. Reeve sculp. // Christ Church Cathedral Oxford // Published April 10, 1807, by R. Reeve, 7, Vere Street, Bond Street*
Ashmolean Museum (Hope Collection)
LIT: Rawlinson 1913, no. 813; Robert Yardley, 'Picture Notes', *Turner Studies*, V/1 (1985), pp. 56–7, Herrmann 1990, p. 72

## 20 [fig. 18, not exhibited]
*Christ Church from near Carfax*

c. 1796
watercolours over pencil with pen and dark ink, 250 × 331
signed, lower centre, *W Turner*
PROV: 3rd Earl of Mansfield; by descent to 6th Earl; Kenwood sale, 8 November 1922, one of lots 696–8; Cotswold Gallery, from whom purchased
National Gallery of Canada, Ottawa
LIT: Wilton, 1979, no. 165 (c. 1796); Youngblood 1984, p. 11

## 21 [fig. 19, not exhibited]
*Canterbury Gate, Christ Church*

?c. 1796
watercolours over pencil, 250 × 333
PROV: as no. 20, until 1922; Sir Leicester Harmsworth; Meatyard; Cotswold Gallery, 1935; R. Stuart-Lomas; Sotheby's, 22 March 1979, lot 145, bt Agnew; private collection
LIT: Wilton, 1979, no. 306 (c. 1800)

## 22 [pl. 11]
*Canterbury Gate, Christ Church*

c. 1799
watercolours and bodycolours over pencil, 256 × 408
PROV: T.B. XLVIII-5
Tate Gallery (D02240)
LIT: Finberg 1909, I, p. 123 (1799-1802)
from the 'Smaller Fonthill' Sketchbook

## 23 [fig. 20, not exhibited]
*Tom Tower from the Canons' Garden*

?c. 1796
pencil, 235 × 190
PROV: T.B. L-V
Tate Gallery (D02363)

LIT: Finberg 1909, I, p. 128 (1799–1801)

## 24 [fig. 21]
*Tom Tower from the Canons' Garden*

c. 1796
watercolours over pencil, 323 × 222
PROV: as no. 20, until 1922; Sir Harold Harmsworth; Cotswold Gallery; Spink, 1953, from whom purchased
Lent from a private collection

## 25 [fig. 22, not exhibited]
*Christ Church Hall from the Staircase*

c. 1799–1800
pencil, 190 × 235
PROV: T.B. L-W
Tate Gallery (D02364)
LIT: Finberg 1909, I, p. 128 (1799–1801)

## 26 [fig. 23]
*Christ Church Hall from the Staircase*

c. 1799–1800
pencil and watercolour, 220 × 322
PROV: as no. 20 until 1922; Cotswold Gallery, 1924, no. 15; purchased (Billborough Bequest), 1924
Lent by Leeds City Art Galleries (514/24)
LIT: Wilton, 1979, no. 305 (c. 1800)

## 27 [fig. 25]
*Interior of New College Chapel, looking East*

c. 1798–1800
pencil and touches of watercolour, 742 × 530
PROV: T.B. L-E
Tate Gallery (D02346)
LIT: Finberg 1909, I, p. 126 ('Interior of All Souls' College Chapel',

1799–1801); Youngblood 1984, p. 16 (All Souls' Chapel); London 1992–3, p. 109, n. 12

**28** [fig. 24]
*Interior of New College Chapel, looking through the organ screen towards Reynolds's west window*

*c.* 1798–1800
pencil and watercolours, 754 × 540
PROV: T.B. L-F
Tate Gallery (D02347)
EXH: London 1992–3, no. 64
LIT: Finberg 1909, I, p. 126 (1799–1801); Youngblood 1984, p. 16 ('All Souls' Chapel')

**29** [fig. 26]
*Interior of Christ Church Cathedral, looking past the Crossing and Organ Screen into the Chancel*

*c.* 1798–1800
pencil and watercolour and white bodycolour, 500 × 677
PROV: T.B. L-G
Tate Gallery (D02348)
EXH: London 1980–81, no. 14; London 1989/1, no. 30
LIT: Finberg, 1909, I, p. 127 (1799–1801); Youngblood 1984, p. 16

**30** [pl. 4, fig. 27]
*Folly Bridge, Oxford*

*c.* 1794
pencil and watercolours, 203 × 267
inscribed (?signed) *J M W Turne*r
and inscribed on verso, *Folly Bridge Oxford 1800*
PROV: G. E. J. Powell, by whom bequeathed
University College of Wales, Aberystwyth
LIT: Wilton, 1979, no. 132 (*c.* 1795); Robert Meyrick and Neil Holland, *To Instruct and Inspire* (Aberystwyth, 1997), p. 3

**31** [fig. 28]
*Folly Bridge from the South East*

*c.* 1797
pencil and watercolours, 205 × 263
PROV: T.B. XLIV-C
Tate Gallery (D01879)
LIT: Finberg 1909, I, p. 107 ('Two-Arched Bridge, with heavy buttresses; houses on either side' *c.* 1798)

**32** [fig. 29, not exhibited]
*Folly Bridge from the North-West*

*c.* 1797
pencil, 207 × 267
inscr. verso, *Isis Bridge Oxford*
PROV: T.B. L-S
Tate Gallery (D02360)
LIT: Finberg 1909, I, p. 128 (1799–1801)

**33** [not exhibited]
*Christ Church from the River*

pencil, 271 × 413
PROV: T.B. XLVIII-2
Tate Gallery (D02237)
from the 'Smaller Fonthill' sketchbook

**34** [pl. 10]
*Christ Church from the Isis*

?1799
watercolours over traces of pencil, 255 × 410
inscribed on verso, *61 Christ Church Coll. Oxford*
PROV: T.B. CXXI-G
Tate Gallery (D08262)
EXH: London 1980, no. 19; Madrid 1983, no. 9
LIT: Finberg 1909, I, p. 333 (*c.* 1802–10)

**35** [not exhibited]
*Merton College from the Meadows*

*c.* 1801
watercolours, 255 × 400
PROV: J. E. Taylor; Christie's, 8 July

1912, lot 105, bt Agnew; J. E. T. Allen, and by descent
Untraced private collection
LIT: Wilton 1979, no. 408

**36** [fig. 45]
*The High Street looking West*

?*c.* 1800
pencil, 408 × 507
PROV: T.B. CXX-F
Tate Gallery (D08219)
LIT: Finberg 1909, I, p. 328 (1802–10), 'sketch for the picture exhibited at R.A. 1812, and now in possession of Lady Wantage'

**37** [fig. 44, not exhibited]
*The High Street looking West*

*c.* 1800
pencil, 213 × 241
PROV: T.B. XXVII-E
Tate Gallery (D00666)
LIT: Finberg 1909, I, p. 54 (1795)

**38** [fig. 46, not exhibited]
*Studies of Parts of the High Street Front of All Souls College and University College*

*c.* 1798
pencil, 144 × 207
PROV: T.B. L-R
Tate Gallery (D02359)
LIT: Finberg 1909, I, p. 128 (1799–1801), 'An Oxford College (Query St John's)'

**39** [fig. 30]
*Christ Church from the Cornmarket*

*c.* 1798
pencil, 212 × 260
inscribed *Roe Buck Randall Hat Manufacturer Turner Drawing Merchants PROBATE*
wmk J WHATMAN 1794

PROV: T.B. XXVII-D
Tate Gallery (D00665)
LIT: Finberg 1909, I, p. 54 (1795)

**40a** [pl. 12]
*South View of Christ Church, &c. from the Meadows*

c. 1798–9
watercolours, with some pen and black ink, over pencil, 315 × 451
PROV: deposited by the Delegates of the Clarendon Press, 1850
Ashmolean Museum (1850.48)
LIT: Herrmann, 1968, no. 1; Petter 1974, p. 81; Wilton, 1979, no. 295; Youngblood 1984, p. 14; Herrmann 1990, pp. 14, 15

**40b**
James Basire after Turner
*South View of Christ Church, &c. from the Meadows*

etching
Lent by the Trustees of the British Museum.(1878-1-12-249)
LIT: Rawlinson 1908 no. 38, proof a

**40c**
ENGRAVER'S PLATE
Lent by kind permission of the Secretary to the Delegates of the University Press

**41** [pl. 13, fig. 32]
*A View of the Chapel and Hall of Oriel College, &c.*

c. 1798–9
watercolours over pencil, 312 × 440
signed in ink, lower left, *W. Turner*
PROV: as no. 40
Ashmolean Museum (1850.49)
LIT: Herrmann, 1968, no. 2; Petter 1974, p. 82; Wilton, 1979, no. 296; Youngblood 1984, pp. 14–15, fig. 20; Herrmann 1990, p. 14

**42a** [pl. 15]
*Inside View of the East End of Merton College Chapel*

1801
watercolours over pencil, with some scratching out, 318 × 444
PROV: as no. 40
Ashmolean Museum (1850.50)
LIT: Herrmann, 1968, no. 3; Petter 1974, p. 82; Wilton, 1979, no. 297; Youngblood 1984, p. 14

**42b**
James Basire after Turner
*Inside View of the East End of Merton College Chapel*
etching and engraving
Lent by the Trustees of the British Museum (1866-11-14-479)
LIT: Rawlinson 1908, no. 40, proof

**43a** [pl. 14]
*A View of Worcester College, &c.*

c. 1803–4
watercolours over pencil, 320 × 443
signed, lower right, *J. M. W. Turner*
PROV: as no. 40
Ashmolean Museum (1850.52)
LIT: Herrmann, 1968, no. 4; Petter 1974, pp. 82–3; Wilton, 1979, no. 298; Youngblood 1984, pp. 17–18; Herrmann 1990, pp. 16–17; Brown 1990, p. 96

**43b** [fig. 34]
James Basire after Turner
*A View of Worcester College, &c.*
etching and engraving
Lent by the Trustees of the British Museum (1866-11-14-472)
LIT: Rawlinson 1908, no. 41, published state

**44** [pl. 16, fig. 35]
*A View from the Inside of Brazen Nose College Quadrangle*

c. 1803–4
watercolours over pencil, 316 × 446
PROV: as no. 40
Ashmolean Museum (1850.53)
LIT: Herrmann, 1968, no. 5; Petter 1974, p. 83; Wilton, 1979, no. 299; Youngblood 1984, pp. 15–16

**45** [pl. 17, fig. 36]
*View of Exeter College, All Saints Church &c. from the Turl*

c. 1803–4
watercolours over pencil, 321 × 450
PROV: as no. 40
Ashmolean Museum (1850.54)
LIT: Herrmann, 1968, no. 6; Petter 1974, p. 83; Wilton, 1979, no. 300; Youngblood 1984, pp. 17–18

**46** [fig. 37]
*Inside View of the Hall of Christ Church*

c. 1799–1800
pencil, 348 × 482
inscr. in margin, *Arms of the Screen Blue*
PROV: T.B. L-J
Tate Gallery (D02351)
LIT: Finberg 1909, I, p. 127; Youngblood 1984, p. 17; London 1992–3, pp. 59–60

**47** [pl. 18, fig. 38]
*Inside View of the Hall of Christ Church*

c. 1803–4
watercolours over pencil, with scratching out, 329 × 448
PROV: as no. 40
Ashmolean Museum (1850.55)
LIT: Herrmann, 1968, no. 7; Petter

1974, pp. 16, 83–4; Wilton, 1979, no. 301; Youngblood 1984, p. 17; Herrmann 1990, p. 15

## 48a [pl. 19]

*A View of Oxford from the South Side of Heddington Hill*

c. 1803–4
watercolours over pencil, with some scratching out, 316 × 448
PROV: as no. 40
Ashmolean Museum (1850.56)
LIT: Herrmann, 1968, no. 8; Petter 1974, pp. 16, 84; Wilton, 1979, no. 302; Youngblood 1984, p. 14; Herrmann 1990, p. 17

## 48b,c

James Basire after Turner
*A View of Oxford from the South Side of Heddington Hill*

etching; etching and engraving
Lent by the Trustees of the British Museum (1866-11-14-493, 1878-1-12-248)
LIT: Rawlinson 1908, no. 45, pure etching and proof c

## 49 [fig. 40]

*Part of Balliol College Quadrangle*

c. 1803–4
watercolours over pencil, 318 × 447
PROV: as no. 40
Ashmolean Museum (1850.58)
LIT: Herrmann, 1968, no. 9; Petter 1974, pp. 16–17, 84–5; Wilton, 1979, no. 303 (1803–4); Youngblood 1984, p. 16; Herrmann 1990, p. 17

## 50a [fig. 41]

*View of the Cathedral of Christ Church, and Part of Corpus Christi College*

c. 1803–4

watercolours over pencil, 316 × 447
PROV: as no. 40
Ashmolean Museum (1850.59)
LIT: Herrmann, 1968, no. 10; Petter 1974, pp. 16, 85–6; Wilton, 1979, no. 304; Youngblood 1984, p. 18; Herrmann 1990, p. 14

## 50b

James Basire after Turner
*View of the Cathedral of Christ Church and Part of Corpus Christi College*

etching and engraving
inscr. by Turner in ink, *Tom is not like. Get Dayes or Rooker's or Delamotte's look at. It has Crocketts at the angles up to the sets of the leadwork*
PROV: W. G. Rawlinson (L.2624); Sir Stephen Courtauld; Sotheby's, 5 December 1996, lot 197, bt Christopher Mendez for O.U.P.
Lent by kind permission of the Secretary to the Delegates of the University Press
LIT: Rawlinson 1908, no. 47, proof c

## 50c

As 50b, later state
Lent by the Trustees of the British Museum (1866-11-14-488)
LIT: Rawlinson 1908, no. 47, proof e

## 50d

ENGRAVER'S PLATE

Lent by kind permission of the Secretary to the Delegates of the University Press

## 51a [pl. 20]

*High Street, Oxford*

1809–10
oil on canvas, 685 × 995
signed lower right, *J. M. W. Turner R.A.*

The Loyd Collection, on long-term loan to the Ashmolean Museum (L.97.141)
PROV: Jesse Watts Russell; Christie's, 3 July 1875, no. 30, bt Agnew's; bt Lord Overstone; by descent
EXH: Turner's Gallery 1810, no. 3; R.A. 1812, no. 161; London 1974–5, no. 159; Oxford, 1993, no. 60
LIT: Butlin and Joll 1984, no. 102 (with full bibliography); Hawes 1982, pp. 106–7; London 1989, p. 9; Herrmann 1990, pp. 74–6; Brown 1990, p. 129; *Canaletto and England* (exh. cat. ed. Michael Liversedge, Jane Farrington, Birmingham Museums and Art Gallery, 1993–4), pp. 106–9

## 51b [fig. 47]

John Pye, Samuel Middiman and Charles Heath after Turner
*High Street, Oxford*

etching and engraving
Lent by the Trustees of the British Museum (1857-5-20-444)
LIT: Rawlinson 1908, no. 79

## 52 [fig. 48]

*View of Oxford from the Abingdon Road*

1811
pencil, 533 × 743
inscr. in pencil with annotations, *rushes, gravel, BB, water, road, corn meadow*
wmk J. WHATMAN 1811
PROV: T.B. CXCV (a) A
Tate Gallery (D17151)
LIT: Finberg 1909, I, p. 597 (1810–20); Butlin and Joll 1984, under no. 125
Recent remounting has confirmed that Finberg was mistaken in reading the watermark as 1814; it is clearly 1811, as had long been suspected.

**53a** [pl. 21]

*View of Oxford from the Abingdon Road*

1811–12

oil on canvas, 660 × 975

PROV: sold with its companion to Jesse Watts Russell; Christie's, 3 July 1875, lot 31, bt Agnew; John (later Sir) Fowler; Christie's, 6 May 1899, lot 80, bt Tooth; bt Agnew, 1915; Victor Reinaecker, 1922; C. Morland Agnew, 1924; his executors, from whom bt Agnew, 1949; H. P .F. Borthwick Norton; his widow, from whom bt Agnew, 1953; bt Leggatt, by whom sold to a private collector

Lent from a private collection

EXH: R.A. 1812, no. 169; London 1974–5, no. 160

LIT: Butlin and Joll 1984, no. 125 (with full bibliography); London 1989/II, p. 9

**53b** [fig. 49]

John Pye and Charles Heath after Turner

*Oxford from the Abingdon Road*

etching and engraving

Lent by the Trustees of the British Museum (1866-9-21-1)

LIT: Rawlinson 1908, no. 125; Herrmann 1990, pp. 75–6

**54** [pl. 23]

*Christ Church College, Oxford*

*c.* 1832

watercolours and bodycolours and scratching out, 299 × 419

PROV: Charles Heath; ? John Ruskin, August 1840–February 1846;[3] H. A. J. Munro of Novar; Christie's, 2 June 1877, lot 48, bt Vokins; Mrs Morris; Howarth 1915; Mrs Brocklehurst, 1917; G. E. Leeming; Agnew 1920; S. A. Courtauld 1925; by descent; Sotheby's, 12 April 1995, lot 81 Messrs Thomas Agnew & Sons Ltd

EXH: London 1833; London 2000, no. 29

LIT: Armstrong 1902, p. 269; Rawlinson 1908, no. 277; Wilton, 1979, no. 853; Shanes 1983, no. 62; Herrmann 1990, pp. 131–2; Shanes 1990, no. 197

**55** [pl. 22]

*Merton College*

1838

brush in red and grey inks and watercolours with some scraping out, 293 × 434

wmk J WHATMAN / TURKEY MILL / 1825

PROV: T.B. CCLXIII-349

Tate Gallery

EXH: Lisbon 1973, no. 26; London 1988, no. 41; London 1992, no. 18; Madrid and Barcelona 1993–4, no. 66

LIT: Finberg 1909, II, p. 841 (1820–30, Exeter College, Oxford); Rawlinson p. 14; Petter 1974, p. 16; Wilton, 1979, no. 887 (*c.* 1830); Shanes 1990, no. 224

based on a pencil study in the 'Oxford' sketchbook (T.B. CCLXXXV-23v.)

**56** [pl. 24]

*High Street, Oxford: Colour Beginning*

*c.* 1835–8

watercolours, 304 × 484

PROV: T.B. CCLXIII-3

Tate Gallery (D25125)

EXH: R.A. 1974, no. 444; The Hague 1978, no. 52; London 1992, no. 23

LIT: Finberg 1909, II, p. 814 (1820–30); Gage 1987, pp. 86–8

**57** [pl. 25]

*High Street, Oxford: Colour Beginning*

*c.* 1835–8

watercolours, 162 × 486

PROV: T.B. CCLXIII-4

Tate Gallery (D25126)

EXH: R.A. 1974, p. 125, no. 445; London 1992, no. 24

LIT: Finberg 1909, II, p. 814 (1820–30); Gage 1987, pp. 86–8

**58** [pl. 26]

*High Street, Oxford: Colour Beginning*

*c.* 1835–8

watercolours, 372 × 547

PROV: T.B. CCLXIII-5

Tate Gallery (D25127)

EXH: R.A. 1974, no. 446; London 1992, no. 22

LIT: Finberg 1909, II, p. 814 (1820–30); Gage 1987, pp. 86–8

**59** [pl. 27]

*High Street, Oxford: Colour Beginning*

*c.* 1835–8

watercolours, 352 × 514

PROV: T.B. CCLXIII-106

Tate Gallery (D25228)

EXH: R.A. 1974, no. 443; Hamburg 1976, no. 92; The Hague 1978, no. 53; London 1992, no. 25

LIT: Finberg 1909, II, p. 822 (1820–30); Gage 1987, pp. 86–8

**60** [pl. 28]

*High Street, Oxford: Colour Beginning*

*c.* 1835–8

watercolours and pencil, 382 × 558

PROV: T.B. CCLXIII-362

Tate Gallery (D25485)

EXH: London 1974, no. 447; London 1989, no. 25; London 1992, no. 26

LIT: Finberg 1909, II, p. 843 (1820–30); Shanes 1990, no. 225; Gage 1987, pp. 86–8

**61** [pl. 29]

*High Street, Oxford: Colour Beginning*

*c.* 1837–8

watercolours, 376 × 555
wmk J WHATMAN 1837
PROV: T.B. CCCLXV-26
Tate Gallery (D36316)
EXH: London 1997, no. 85
LIT: Finberg 1909, II, p. 1213 ('Street Scene, with church tower')

## 62 [pl. 32]
*Trinity College: Colour Beginning*

*c.* 1837–8
watercolours, 342 × 503
PROV: T.B. CCLXIII-95
Tate Gallery (D25217)
EXH: London 1997, no. 84
LIT: Finberg 1909, I, p. 821 (1820–30, 'road leading to cathedral [?] in middle distance')

## 63
*St John's and Trinity Colleges: Colour Beginning*

*c.* 1837–8
watercolours, 340 × 505
PROV: T.B. CCLXIII-96
Tate Gallery (D25218)
EXH: London 1997, no. 82
LIT: Finberg 1909, II, p. 821 (1820–30, 'Landscape, with mansions and trees')

## 64
*New College: Colour Beginning*

*c.* 1837–8
watercolours, 348 × 508
PROV: T.B. CCCLXV-24
Tate Gallery (D36314)
EXH: London 1995, no. 81
LIT: Finberg 1909, II, p. 1213 ('Promenade with figures')

## 65 [pl. 30]
*Oxford from North Hinksey: Colour Beginning*

?*c.* 1839
watercolours, 344 × 501
PROV: T.B.. CCLXIII-98
Tate Gallery (D25220)

EXH: London 1997, no. 80
LIT: Finberg 1909, II, p. 821 ('A Sunny Landscape')

## 66a [pl. 31, fig. 56]
*Oxford from North Hinksey*

*c.* 1839
water and body colours, 352 × 516
PROV: ?given by the artist to James Ryman; H. A. J. Munro of Novar; Christie's, 6 April 1878, lot 81, bt Agnew's; J. S. Kennedy; Christie's, 18 May 1895, lot 94, bt Tooth; Wallis & Son; The French Gallery; James Blair, by whom bequeathed, 1917
City Art Gallery, Manchester (1917–102)
EXH: Manchester, 1982, no. 26; Bordeaux and Calais 1983–4, no. 26; Stockholm, 1984, no. 39; Tokyo and Osaka 1985, no. 34: Cincinatti 1986, no. 50; Memphis etc. 1997–8, no. 55
LIT: Finberg 1939, p. 348; Wilton, 1979, no. 889 (*c.* 1835–40); Eric Shanes, 'Picture Notes', in *Turner Studies* 1/2 (1981), p. 52; Shanes 1990, no. 226

## 66b,c [figs. 57, 58]
Edward Goodall after Turner
*Oxford from North Hinksey*

b. etching
PROV: Turner's studio sale (L.1489)
c. etching and engraving
lettered, *Engraved by F. Goodall after a Drawing by J. M. W. Turner R. A.*
Ashmolean Museum (OA 322-3)
LIT: Rawlinson 1908, no. 651; Herrmann 1990, p. 229

These are the first and fourth states, unrecorded by Rawlinson; the second was offered by Michael Campbell Fine Art, *British and European Prints*, 8 (2000), no. 87; the third, a touched impression recorded by Rawlinson from his own collection, was offered at Sotheby's, 5 December 1996, lot 198

## Notes to the Catalogue

1 According to a typewritten label on the back board.
2 See Stephen Coppel, 'George Salting and his Turner Watercolours', *Apollo* CLI (2000), pp. 41–7 (47).
3 Ian Warrell in London 2000, argues that this is Turner's watercolour of Oxford for which Ruskin paid £50 in August 1840, and which he exchanged in February 1846 with Munro of Novar. This is probable, but the references are too vague to be certain.

# Bibliographical References

For architectural details, I have relied on standard sources:
*The Victoria History of the County of Oxfordshire*, ed. H. E. Salter and Mary D. Lobel, III, The University of Oxford (London, 1954); Jennifer Sharwood and Nikolaus Pevsner, *Oxfordshire, The Buildings of England* (Harmondsworth, 1974); Howard Colvin, *A Biographical Dictionary of British Architects 1600–1840*, third edn (New Haven and London, 1995); and Geoffrey Tyack, *Oxford: An Architectural Guide* (Oxford, 1998).

Athens 1981
'J. M.W. Turner (1775–1851)', National Pinakothiki, Alexander Soutzos Museum, Athens, 1981

Bell 1904
C. F. Bell, 'The Oxford Almanacks', *Art Journal* LXVI (1904), pp. 241–6

Binyon 1896
L. Binyon, *Catalogue of Drawings by British Artists ... in the British Museum*, 4 vols (London, 1898–1907)

Bordeaux and Calais 1983–4
'J. M. W. Turner: Aquarelles de la City Art Gallery, Manchester', Musée des Beaux-Arts, Bordeaux and Musée des Beaux-Arts et de la Dentelle, Calais

Brown 1990
David Blayney Brown, *The Art of J. M.W. Turner* (London, 1990)

Butlin and Joll 1984
Martin Butlin and Evelyn Joll, *The Paintings of J. M.W. Turner*, rev. edn, 2 vols (New Haven and London, 1984)

Cambridge 1994
'British Landscape Watercolours 1750–1850', Fitzwilliam Museum, Cambridge, 1994 (cat. by Jane Munro)

Cincinatti 1986
'J. M.W. Turner: The Foundations of Genius', Taft Museum, Cincinatti, 1986 (cat. by Eric Shanes)

Farington, *Diary*
*The Diary of Joseph Farington*, 16 vols, ed. Kenneth Garlick and Angus Macintyre (I–VI), Kathryn Cave (VII–XVI) (New Haven and London, 1978–84)

Finberg 1909
A. J. Finberg, *A Complete Inventory of the Drawings in the Turner Bequest*, 2 vols (London, 1909)

Finberg 1910
A. J. Finberg, *Turner's Sketches and Drawings* (London, 1910)

Finberg 1939
A. J. Finberg, *The Life of J. M.W. Turner, R.A.* (Oxford, 1939)

Gage 1969
John Gage, *Colour in Turner: Poetry and Truth* (London, 1969)

Gage 1980
John Gage, *Collected Correspondence of J. M.W. Turner* (Oxford, 1980)

Gage 1987
John Gage, *J. M.W. Turner: 'A Wonderful Range of Mind'* (New Haven and London, 1987)

Hamilton 1997
James Hamilton, *Turner: A Life* (London, 1997)

Hawes 1982
Louis Hawes, *Presences of Nature: British Landscape 1780–1830* (New Haven, 1982)

Herrmann 1968
Luke Herrmann, *Ruskin and Turner: A Study of Ruskin as a Collector of Turner, based on his Gifts to the University of Oxford; incorporating a Catalogue Raisonné of the Turner Drawings in the Ashmolean Museum* (London, 1968)

Herrmann 1990
Luke Herrmann, *Turner Prints: The Engraved Work of J. M.W. Turner* (Oxford, 1990)

Hill 1993
David Hill, *Turner on the Thames: River Journeys in the year 1805* (New Haven and London, 1993)

Lisbon 1973
'Turner 1775/1851: Desenhos aguarelas e oleos', Fundação Calouste Gulbenkian, Lisbon, 1973

London 1833
'Private Exhibition of Drawings by J. M.W. Turner, R.A.', Messrs Moon, Boys & Graves, 6, Pall Mall

London 1974–5
'Turner 1775–1851', Tate Gallery and Royal Academy, 1974–5

London 1975
'Turner in the British Museum: Drawings and Watercolours', British Museum, 1975 (cat. by Andrew Wilton)

London 1980
'Turner at the Bankside Gallery', London 1980

London 1980–81
'Turner and the Sublime', Art Gallery of Ontario, Yale Center for British Art, British Museum 1980–81 (cat. by Andrew Wilton)

London 1988
'Turner and Architecture', Tate Gallery, London, 1988 (cat. by Ian Warrell and Diane Perkins)

London 1989/I
'Young Turner: Early Work to 1800; Watercolours and Drawings from the Turner Bequest 1787–1800', Tate Gallery, London, 1989 (cat. by Anne Lyles)

London 1989/II
'Turner and the Human Figure: Studies

of Contemporary Life' Tate Gallery, London, 1989 (cat. by Ann Chumbley and Ian Warrell)

London 1992
'Turner: The Fifth Decade; Watercolours 1830–1840', Tate Gallery, London, 1992 (cat. by Anne Lyles)

London 1992–3
'Turner as Professor: The Artist and Linear Perspective', Tate Gallery, London, 1992–3 (cat. by Maurice Davies)

London 1997
'Turner's Watercolour Explorations', Tate Gallery, London, 1997 (cat. by Eric Shanes)

London 2000
'Ruskin, Turner and the Pre-Raphaelites', Tate Gallery, London, 2000 (cat. by Robert Hewison, Ian Warrell, Stephen Wildman)

Madrid 1983
'J. M. W. Turner: Dibujos y acquarelas del Museo Britanico', Museo del Prado, Madrid, 1983

Manchester 1982
'Turner at Manchester: Catalogue raisonné of the Collections of the City Art Gallery' (Milan, 1982) (cat. by T. P. P. Clifford)

Manchester 1984
'Turner Watercolours in the Whitworth Art Gallery', Whitworth Art Gallery, Manchester, 1984 (cat. by Craig Hartley)

Memphis etc. 1997–8
'Turner Watercolours from Manchester', Memphis Brooks Museum of Art; Indianapolis Museum of Art; Joslyn Museum of Art, Omaha, Nebraska; Whitworth Art Gallery, Manchester, 1997–8 (cat. by Charles Nugent and Melva Croal)

Mexico City 1979
'Exposicion del gran pintor ingles William Turner, oleos y acurelas; colecciones de la Tate Gallery, British Museum y otros museos ingleses', Museo de arte moderno, Bosque de Chapultepec, Mexico City, 1979

Oxford 1993
'Hidden Treasures: Works of Art from Oxfordshire Private Collections', Ashmolean Museum, 1993 (cat. by Catherine Whistler, Christopher White, Rosemary Baird)

Oxford 1998
'John Malchair of Oxford, Artist and Musician', Ashmolean Museum, Oxford, 1998 (cat. by Colin Harrison)

Payne 1991
Christiana Payne, 'Boundless Harvests: Representations of Open Fields and Gleaning in Early Nineteenth Century England', *Turner Studies*, XI /1 (summer 1991), pp. 7–15

Petter
Helen Mary Petter, *The Oxford Almanacks* (Oxford, 1974)

Rawlinson 1886
W. G. Rawlinson, 'Turner's Drawings at the Royal Academy', *The Nineteenth Century*, 1886, p. 404

Rawlinson 1908, 1913
W. G. Rawlinson, *The Engraved Work of J. M. W. Turner, R. A.*, 2 vols (London, 1908, 1913)

Shanes 1979
Eric Shanes, *Turner's Picturesque Views in England and Wales 1825–1838* (London, 1979)

Shanes 1983
Eric Shanes, *Turner's Picturesque Views in England and Wales 1825–1838* (London, 1983)

Shanes 1984
Eric Shanes, 'New Light on the "England and Wales" Series', *Turner Studies*, IV /1 (1984), pp. 52–4

Shanes 1990
Eric Shanes, *Turner's England 1810–1838* (London, 1990)

Stockholm 1984
'J. M. W. Turner: Akvareller, Målningar, Grafik', Nationalmuseum, Stockholm, 1984

The Hague 1978
'Turner 1775–1851', Haags Gemeente-museum, The Hague, 1978–9

Tokyo and Osaka 1985
'Turner at Manchester', Odakyu Grand Gallery, Tokyo and Daimaru Museum of Art, Osaka, 1985

Tyrrell-Gill 1904
Frances Tyrrell-Gill, *Turner* (London, 1904)

Whittingham 1999
Selby Whittingham, 'Of Geese, Mallards and Drakes: Some Notes on Turner's Family, IV – The Marshalls and the Harpurs', 2 vols, privately printed for J. M. W. Turner R.A. Publications (London, 1999)

Wilton 1979
Andrew Wilton, *The Life and Work of J. M. W. Turner* (London, 1979)

Wilton 1987
Andrew Wilton, *Turner in his Time* (London, 1987)

Youngblood 1984
Patrick Youngblood, 'The Stones of Oxford: Turner's Depiction of Oxonian Architecture', *Turner Studies*, III/2 (1984), pp. 3–21